D1584768

YORK
IN
50
BUILDINGS

ANDREW GRAHAM

AMBERLEY

First published 2018

Amberley Publishing, The Hill, Stroud
Gloucestershire GL5 4EP

www.amberley-books.com

British Library Cataloguing in Publication Data.
A catalogue record for this book is available from the British Library.

ISBN 978 1 4456 7408 7 (print)
ISBN 978 1 4456 7409 4 (ebook)

Origination by Amberley Publishing.
Printed in Great Britain.

Contents

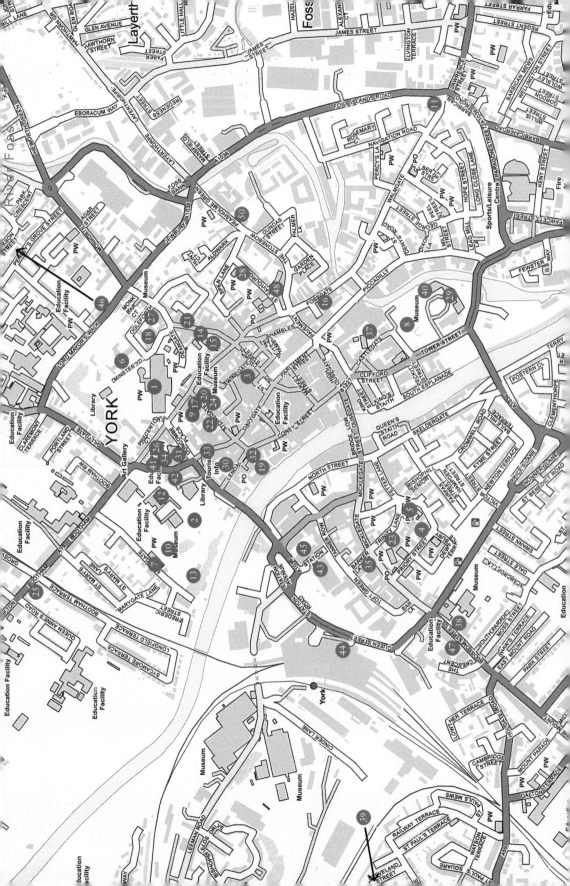

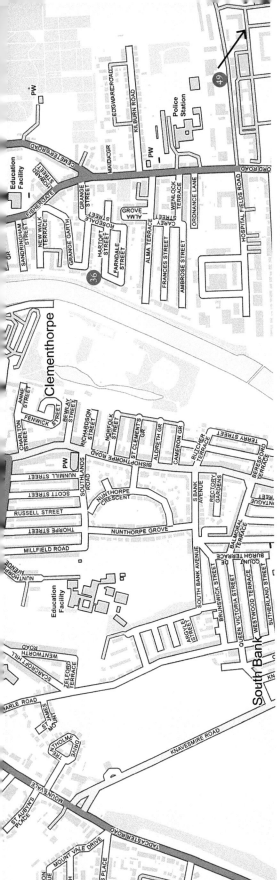

Key

1. York Minster
2. Multangular Tower, Museum Gardens
3. Roman Bath Inn, St Sampson's Square
4. Church of Holy Trinity, Micklegate
5. St Mary Bishophill Junior
6. Treasurer's House
7. St Olave's Church, Marygate
8. Clifford's Tower/York Castle
9. The Norman House, Behind No. 48 Stonegate
10. St Mary's Abbey
11. Walmgate Bar
12. King's Manor
13. Hospitium, Museum Gardens
14. Our Lady Row, Nos 64–72 Goodramgate
15. Holy Trinity, Goodramgate
16. Merchant Adventurers' Hall, Fossgate
17. 'House of the Trembling Madness', No. 48 Stonegate
18. St William's College, College Street
19. Guildhall
20. No. 35 Stonegate
21. No. 51 Goodramgate
22. Ye Olde Starre Inne, No. 40 Stonegate
23. Jacob's Well, Trinity Lane
24. York Medical Society, No. 23 Stonegate
25. Ingram Almshouses, Bootham
26. The Eagle and Child Pub, High Petergate
27. The Dutch House, Ogleforth
28. Unitarian Chapel, St Saviourgate
29. Debtors' Prison
30. The Judge's Lodging, No. 9 Lendal
31. Red House, Duncombe Place
32. Mansion House
33. The Assembly Rooms
34. Theatre Royal
35. Micklegate House, Nos 88–90 Micklegate
36. Pikeing Well, New Walk
37. Fairfax House, No. 27 Castlegate
38. The Bar Convent, Blossom Street
39. Holgate Windmill
40. Female Prison – The Castle Museum
41. De Grey Rooms, St Leonard's Place
42. Nos 1–9 St Leonard's Place
43. Old Station, Railway Street/Tanner Row
44. York Railway Station
45. Former GNER HQ, Railway Street
46. Folk Hall, New Earswick
47. Odeon Cinema, Nos 1–5 Blossom Street
48. Stonebow House, Stonebow
49. Central Hall, University of York
50. Hiscox Building, Peasholme Green

Introduction

This city, first, by Roman hand was form'd with lofty towers, and high built walls adorn'd.
Francis Drake, 'Eboracum', 1736

These are the words of the York historian Francis Drake, writing about his beloved city in the early eighteenth century. The city as he saw it was every bit as fascinating as the one we see today. He still found pieces of Roman tile and sculpture protruding from ancient abbey walls and gazed upon the same Minster with awe.

It has been said that the history of the city of York is the history of England and, apart from only vague evidence of pre-Roman peoples, it is. The city as we know it began with a series of Roman forts that eventually evolved into the mighty legionary fortress of Roman Eboracum. Although the area did have Iron Age and prehistoric communities, many of which were later Romanised, there is little evidence within the city of them anymore – any layers of archaeology are likely too deep or have been destroyed through development of the same ground for the last 2,000 years.

The Roman legacy lives on in the very shape of the city, however, and the streets we walk on to this day follow the general alignment of those laid out nearly 2,000 years ago. The present medieval city walls also closely follow that of the Roman fortress and this is, in part, due to the intentional reuse of the city defences ever since the sixth century. Indeed, it was no coincidence that King Edwin chose this high-status place to build his own modest wooden church in AD 627 alongside what remained of the Roman Basilica. It is a classic tale of leaders trying to associate themselves with powerful figures of the past and today this very spot is where the Minster still stands, the most recent in a series of high-status buildings on the site. If there was post-Roman occupation in the city, evidence for this too is lacking and the first reference we have to York after the fifth century is in the Ravenna Cosmography of around AD 700.

As a result, it was at least a hundred years before the city started to repopulate, but this time the focus of the early medieval town appears to have been outside the fortress walls around Fishergate, where the elusive Anglian settlements were finally discovered in the 1980s. Although Anglian religious centres continued in the Minster and around Bishophill, this was the first time substantial domestic settlement of the early Saxons had been found.

The Vikings also settled to the east of the old fortress and are now famous in York and around the country for their settlement around Coppergate, where long plots of houses, gable end to the street, were excavated during construction of the Coppergate Centre. They now form the attraction Jorvik, which is still, thirty years on from its opening, a great and inspirational trip back in time. The Vikings overlaid the old Roman streets with their own pattern of routes, and these have also subsequently become fossilised in later boundaries. As ancient buildings crumbled and new urban foci emerged, so did

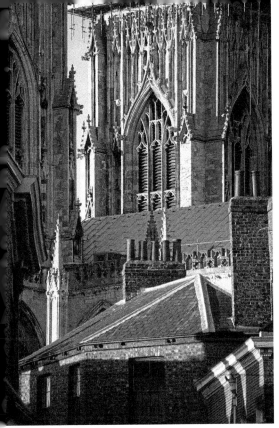 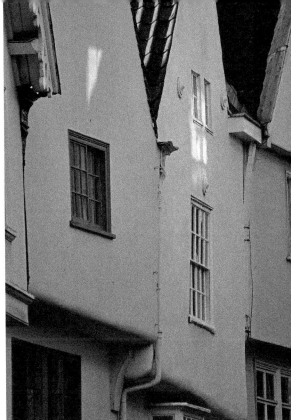

Above left: A classic view along the old Roman Via Principalis, now High Petergate, towards the west towers of York Minster.

Above right: Timber-framed gables facing High Petergate, a distinctive characteristic of the medieval city.

Below: A view along Carrs Lane in Bishophill that may well reflect older street patterns in the Roman colonia.

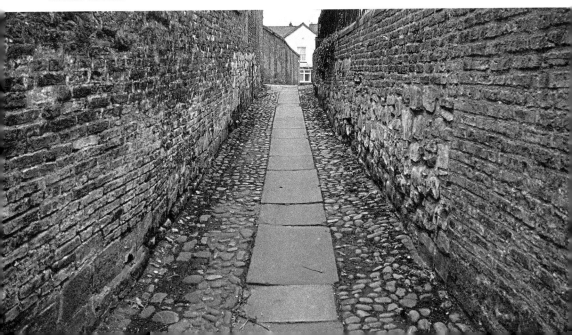

the desire lines and footpaths that gave us the distinctive curving streets we know today, intentionally short-cutting the unforgiving grid iron on the Roman city.

The course of history of York was changed beyond recognition when Harold won the nearby Battle of Stamford Bridge in 1066. Conversely, it was likely this, and his subsequent forced march to the south coast, that led to the Norman victory over Saxon England near Hastings. The first thing William the Conqueror did in Yorkshire was to stamp upon York's two castles in order to halt any more Viking incursions. What he may not have expected, however, was the amount of sympathy for the previous regime that survived in the city and the subsequent rebellions that bubbled up.

As a consequence, the first brutal campaign masterminded from the new castle at York was to lead to the massacres of the 'Harrying of the North' and the city suffered badly as an example and retribution. As a result of this action much of Yorkshire was recorded as waste in the 1086 Domesday Survey and didn't fully recover for several centuries after this.

The Normans, however, give us a valuable glimpse of early architecture in the city. The so-called Norman House, various churches, hospitals and even the foundations of the Minster itself were built by the Normans and this laid the ground for York to become the medieval boom town that it ultimately did.

Eventually the city sported timber-framed buildings of every kind and size, with churches penetrating the skyline at regular intervals. The population at this time grew to its highest level until the eighteenth century and had it not been for plague, fire, economic decline and the English Civil War, the city could have expanded from out of its walls much sooner than it did. This expansion only happened, however, following the city's re-emergence as a popular destination for the great and good of the Georgian period.

The economy of the city in the later medieval era was fast becoming usurped by the cloth-making towns of the West Riding, where trade was much less restricted and free from the controls of the York guilds. This was made worse with the Dissolution of the Monasteries ordered by Henry VIII, which destroyed many of the institutions that had held the city's communities together. Following this many of the ancient religious precincts such as St Mary's were partially demolished and used as quarries by the population. Many churches fell into further disrepair as congregations dropped and the city once again contracted in on itself.

York managed to reinvent itself as a trading centre in the Elizabethan period and as the seventeenth century dawned, the city became something of a fashionable retreat for the wealthy, which resulted in a plethora of wonderful, classically inspired, buildings that dominate the grand streets today, such as Micklegate and Castlegate.

Several ordnances were also passed at this time by Parliament in order to halt the fire risks from timber building, and it is not unusual for a fine Georgian classical façade to be covering up much older timber framing inside. Some of the finest buildings of this period are the Assembly Rooms, Mansion House and Micklegate House, all of which helped spur on the city until its position in the world was secured through the arrival of the railway.

Largely thanks to the 'Railway King', George Hudson, York maintained at least some credibility from its younger upstart cities of Leeds and Bradford when the main railway line from London to Edinburgh came through York. This built upon the ancient connections of the Romans and allowed the city to at least cling onto the hems of its neighbours' economic success.

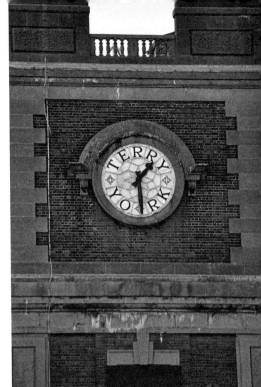

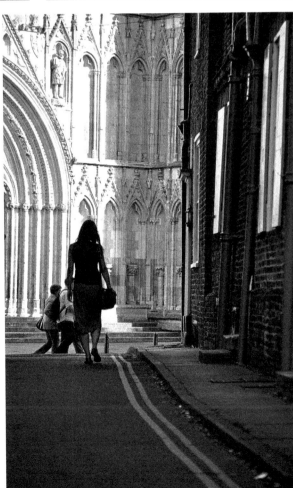

Above left: A classic example of the grandeur of the Georgian city along Micklegate.

Above right: The Terry's chocolate factory tower in York's South Bank area, one of several confectionery giants that were part of the industrialisation of York in the twentieth century.

Right: The quaint streets leading to the Minster that sits on the site of the Roman Headquarters building.

As a consequence, however, York never industrialised in the same way as its neighbours and this resulted in the skies above York being filled with the smells of chocolate as opposed to tanning stench. The city soon became a centre of the confectionery industry, most notably led by Rowntree's and Terry's, both Quaker families.

In the early twentieth century the legacy of Seebohm Rowntree's report on Victorian poverty led to the Quaker family changing the face of residential York forever through the birth of the suburb and the Rowntree model village of New Earswick. The houses, inspired largely by the Arts and Crafts movement, soon inspired whole new suburbs of the city to develop, and by the 1950s whole areas had been amalgamated into the city boundary.

Due in part to this migration to the suburbs, York was threatened by the mass demolitions that many cities suffered. Fortunately, the fate of many towns was avoided, with only a few truly horrendous modernist buildings getting off the ground, and the proposed new ring road was so watered down as to make it almost indistinguishable in many areas.

Today the heritage economy in Yorkshire generates over £900 million a year and York must account for a sizeable chunk of this. As the ancient institutions such as the Minster, York Glaziers Trust, Merchant Taylors and Adventurers' still exist, however, they ultimately create a city that is far from just a tourist town and instead is a truly liveable and sustainable place, in the truest sense of the word.

Author's Note

This book has been a wonderful challenge, not least because of the need to restrict the number of buildings to just fifty, and the reader must forgive me for any glaring omissions. There are so many tales to tell and wonderful features to explore that there are bound to be some harsh edits along the way. However, what I have tried to do is to tell a story of the York I know and love, as well as to attempt to discuss some of the ways in which the city could improve in its future planning of the city public realm and spaces that should show off these buildings. I hope that it inspires people to dig a little further and visit some of these wonderful places with fresh eyes.

The 50 Buildings

1. York Minster (AD 627–date)

He who hath seen York need not regret leaving other cathedrals unseen. It is worth twenty of them together.

Robert Surtees (1779–1834)

The jewel in the crown of Yorkshire and a building impossible to do justice to, York Minster is the second largest Gothic cathedral in northern Europe. It has the largest expanse of stained glass in England and is one of the oldest Christian sites in Britain.

The Minster is located at the very heart of the city upon its most high-status location. It was on this spot 1,700 years ago that the emperor Constantine was proclaimed Emperor by the armies of the north after the death of his father, Constantius Chlorus. It was here that Edwin, King of Northumbria, built his first wooden church in AD 627, where he was baptised and subsequently converted to Christianity.

It was also here that, in 1080, Thomas de Bayeux, the first Archbishop of York, organised the rebuilding of a grand cathedral on par with the best of European medieval churches. This time the building was placed on the correct alignment and subsequently laid the foundations of the great Gothic masterpiece we see today.

The West Front of York Minster with the Heart of Yorkshire window in beautiful ochre tones.

The building of the Gothic church took place in several phases from around the early thirteenth century, when the north and south transepts (the wings north and south of the tower) were reconstructed in the towering vaulted style, complete with the Gothic pointed arches, buttresses and ornate tracery to the windows.

The building today is one of true magnificence, standing at the head of Duncombe Place, which was laid out in the 1850s in order to create a dramatic approach to the building. It is truly iconic, its honey-couloured stone reflecting evening the sunlight.

Most recently the East Front was revealed once more following extensive restoration of the stained glass; all 117 panels were removed, cleaned and re-encased back in their tracery.

The project 'York Minster Revealed' was one of the largest conservation projects in Europe and obtained £10.5 million of funding from the Heritage Lottery Fund – so everyone who buys a lottery ticket really is a winner!

On entering the nave, especially on a cool February day when the low morning sun streams in from the south, the effect is jaw-dropping. The subtlety of light, giant pillars and wooden vaulted roof (which should actually have been stone but was an exercise in medieval value engineering) lead the eye to the rood screen and organ casing, its Gothic English oak carving reaching once again skyward.

The building has seen its fair share of trials and tribulations. In 1407, the Central Tower collapsed in a similar manner to that of nearby Ripon Cathedral. During the Reformation, the building was sacked by Parliamentarians and the empty niches, once filled with the statues of saints, still fill every façade on the outside. If it wasn't for Lord Fairfax, who protected much of the stained glass from destruction, the damage could have been much worse.

On 2 February 1829 'Mad John Martin' hid behind the choir screen after evensong and set fire to the church. This was followed by a second conflagration in 1840.

In the 1970s, the Central Tower was again at risk and sinking into the soft York soil. Described by the then Surveyor of the Fabric as a critical patient in need of immediate surgery, a massive civil engineering project was undertaken to underpin the tower with huge collars of concrete. This allowed archaeologists to investigate beneath the cathedral at the same time, and they discovered the Roman Basilica building, which would have likely been the scene of the most important events in Roman York. The walls of this building can now be seen, complete with beautifully colourful Roman plasterwork among the giant reinforcing concrete of the later repairs.

To top everything off, in 1984 yet another fire was seen lighting up the July sky, with flames streaking upwards from the central crossing. This time the culprit was thought to be lightning. It took four years and over £2 million to restore, which included newly commissioned ceiling bosses designed by the viewers of the BBC television series *Blue Peter*.

Today the Minster has a growing congregation, and this allows it to face the challenges of the twenty-first century more confidently than ever. Notable among these challenges is the preservation and restoration of the fabric of the building – more often than not this involves the replacement of past restorations and repairs that, through the use of inappropriate materials, often cause more damage in the long term.

The stained glass, after bearing the brunt of northern rain for centuries, can become pockmarked and sometimes disintegrate altogether. In the 1980s 120 segments of the 'Heart of Yorkshire Window' on the West Front were meticulously recorded and re-carved

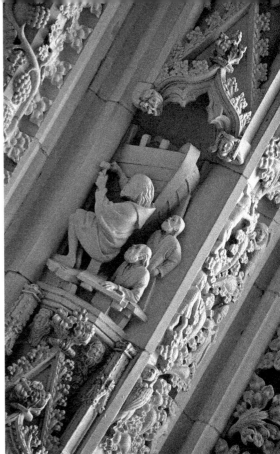

Above left: Some of the many empty niches in the Minster left behind following the Siege of York in the English Civil War.

Above right: The new carving of the Book of Genesis on the West Front doorway. This scene shows Noah building his ark.

Right: The south transept rose window reflecting the late evening sun.

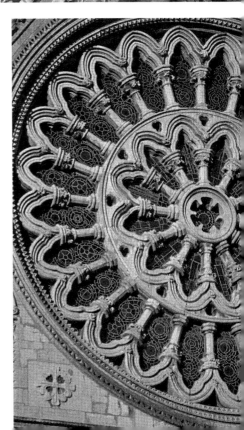

and the Book of Genesis was reinterpreted in incredible detail above our heads. A recent project has also seen much of the medieval stained glass encased, thus preserving it for the future.

The mason's yard and York Glaziers Trust still occupy premises within the precinct and the masons recently unveiled the sculptures of King Solomon and his wives, which have recently taken pride of place upon the highest points, their sculptural forms providing a wonderful and fitting interpretation of a rather contentious Bible story.

Perhaps the biggest challenge, however, is that of climate change. The more frequent storms and heavy rainfall can cause havoc with the Minster's drainage and guttering and further erode the precious, soft limestone. Larger gutters can often solve this problem but the issues that we will face in the future around pollution and a changing climate are still largely unknown. However, under the careful custodianship of the Dean and Chapter, we can hope for a bright future for this beautiful, inspiring and unique structure.

2. Multangular Tower, Museum Gardens, Museum Street (AD 200–250)

The Multangular Tower is perhaps the most prominent and obvious remnant of Roman York and, besides a few odd bits and pieces here and there, the most engaging. It stands majestically in the Museum Gardens, its quadrangular form and lines of red tiles to this day marking out the south-western corner of the Roman legionary fortress.

The fortress was itself the undisputable mark of intention from the Roman army to conquer the rest of Britain in the early AD 70s in order to finally pacify the Brigantes and Parisi tribes north of the Humber.

It was the famous Ninth Legion who set forth from Lincoln and initially set up several temporary camps north of the present-day city, before finally constructing their typically playing card-shaped enclosure on a spur of land between the rivers Ouse and Foss.

The primary routes into the fortress are today still echoed by streets such as High Petergate, Bootham, Stonegate and parts of Micklegate, whose courses have wavered slightly over last two millennia but have still served a continued purpose for the people of York.

The tower in its present form is a late addition to the Roman occupation and it is likely that our most famous emperors to have visited Eboracum – Hadrian and Septimus Severus – would never have actually seen the grand many-angled structure we see today.

Indeed, the style of the tower was synonymous with the buildings in the later empire under Constantine and the appearance of the southern aspect of Eboracum's fort would not have been so far removed from similar buildings as far away as Constantinople and Ravenna, where more ornate defences, complete with decorative bands, were becoming the norm.

The fact that the tower has survived was largely due to the presence of St Leonard's Hospital and St Mary's Abbey, through which the remains of the Roman wall created a convenient boundary to reuse and repair.

Before this, however, there is tantalising evidence of York's elusive Anglian history and on walking through the leafy fern rockery and into the interior of the tower, an earlier stretch of Roman wall was seemingly infilled in the post-Roman period with a tower of much slighter

Above: The Multangular Tower sitting in the Museum Gardens still marks the south-western extremity of the Roman fort. The letters are part of the York Winter Wonderland illuminations.

Below: The course of *saxa quadrata* Roman tiles in red make a distinctive impression to the Roman layers. The upper courses of the tower are later medieval and once formed the boundary of St Leonard's Hospital.

proportions. The so-called Anglian Tower has therefore provided tantalising evidence for the reuse and continued occupation of the city after Roman support stopped flowing.

Today the Multangular Tower is sheltered behind the oak trees of the Museum Gardens and, on summer days, the ice-cream van. It also forms a key part of the Illuminating York festival and the winter festivities around Christmas time when the gardens around the structure are lit up.

3. Roman Bath Inn, St Sampson's Square (Fourth Century/1929)

The Mail Coach Inn on St Sampson's Square was renamed the Roman Bath following the chance find in the 1970s of the Roman legionary fortress bathhouse within its cellar.

The present building is a pleasant Arts and Crafts inspired building of 1929/30 and designed by Mr B. Wilson. Its mock Tudor timber gable and herringbone brickwork, together with stone details and features, relate an unassuming, almost suburban appearance, but the site is one of the few where remains of the Romans can still be appreciated in situ, if for a small fee.

It was relatively unusual to have a bathhouse actually within a Roman fortress and this may account for the sophisticated drainage that still functions beneath the streets of York. Located only a few streets from the location of the Headquarters building, under the Minster, the bathhouse has produced tiles stamped by both the VI and the IX Legions and hints, once again, at the importance of York to the Romans. It is tempting to imagine who used these baths and what the city was like when they did?

Remains of the caldarium (hot room), complete with typical hypocaust stacked tiles, and frigidarium (cold room) can now be visited with permission of the landlord, perhaps following a real ale like so many Romans before us?

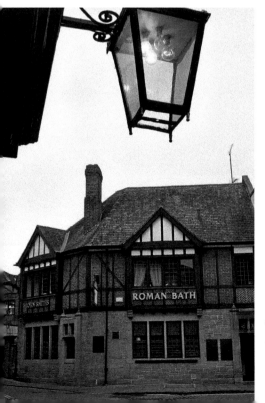

The Roman Bath Inn, formerly The Mail Coach Inn, on St Sampson's Square.

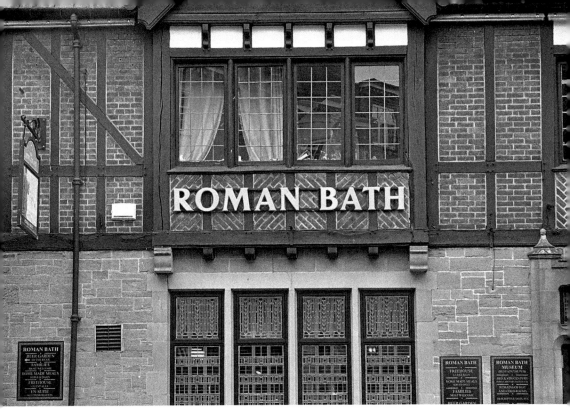

The Arts and Crafts detail of the Roman Bath Inn with timber cladding and herringbone brickwork.

4. Church of Holy Trinity, Micklegate (1157–156os)

The churches of Holy Trinity and Bishophill Junior provide fascinating hints at the early religious foundations in York, and it is very tempting to speculate about the significance of these sites that occupy the high ground to the south of the city, well away from the site of the legionary fortress but close enough to the main Roman thoroughfare to the south that led to Tadcaster (Calcaria).

The sheer amount of ancient churches here, the size of parish boundaries (larger boundaries hinting at earlier foundations) and the amount of reused Roman and pre-Conquest material indicate some prestigious early buildings.

Holy Trinity, or Christ Church as it was known prior to the Conquest, is a prime candidate for the site of the elusive Alma Sophia church that was mentioned by the York scholar Alcuin in the eighth century. Although debate still rages, the jurisdiction of Holy Trinity took in almost all of the former Roman colonia (civil settlement) to the south of the Ouse and respected to some extent the ancient layout of the Roman town.

Holy Trinity, therefore, was one of the great priories of the city and a church here was given to the Benedictine Marmoutier Abbey, near Tours, France, by Ralph Paynel in 1090. Although nothing now remains of this early church, remnants found on site hint at a building of great distinction.

Shortly after the rededication by the Benedictines a new church was constructed that was more than double the size of the present. This building was unfortunately largely destroyed by fire in 1137 and resulted in the nave being abruptly foreshortened by the building of a new wall across it.

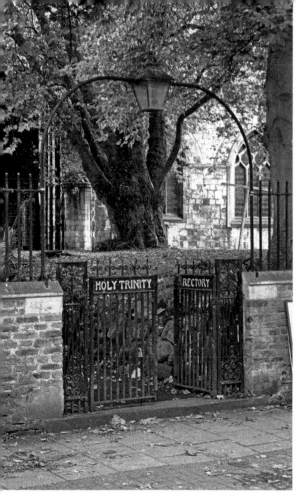

Left: The gateway from Micklegate into Holy Trinity's rectory. The grandeur of this once impressive religious precinct is now mostly disappeared.

Below: The remains of the once grand priory facing Priory Street and providing quite a surprise to the causal visitor.

Detail of the Priory Street elevation.

Evidence for further struggles emerge in 1446 when the church was exempt from taxation due to poverty and, to make matters even worse, the tower collapsed in a storm on 15 February 1551.

The collapse led to the church being used as a quarry to build Ouse Bridge in the 1560s, and the only remains of the earlier buildings today are the two central piers, along with the north end of the nave that stands, or rather leans, as if almost trying to hide behind properties on nearby Priory Street.

This element of the building, incidentally, seems to have stumped even the great Pevsner as he assessed the plethora of architectural motifs. The grandeur of this elevation, however, gives some clue as to the importance of this site in its long and prestigious history.

5. St Mary Bishophill Junior (Eighth Century)

The second church of particular note in Bishophill is the church of St Mary, Bishophill Junior. Its name alone is intriguing, but this church represents one of the oldest extant churches in the city. Its tower is most notable as it reuses at least thirteen pieces of Roman masonry, not including the extensive collation of red Roman tile, and a reused column in its belfry opening.

Inside, there is a great arch that appears to be reused Roman, if only for the fact that it dwarfs everything else in the church in terms of scale as well as workmanship. This arch was noticed by Drake, in the eighteenth century in his search for Roman bits and pieces within

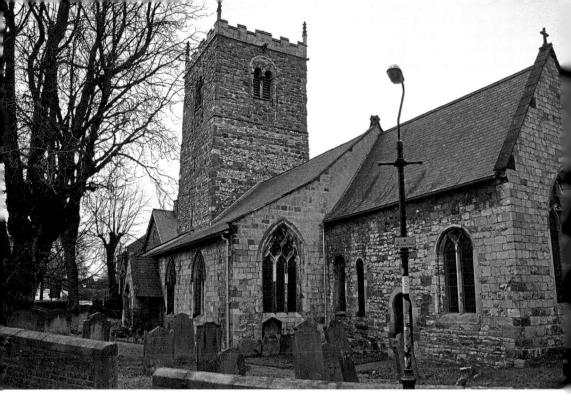

Above: Bishophill Junior with its early tower.

Below left: The detail of the stonework of Bishophill Junior that contains Roman tile and Saxon herringbone patterns in its stonework.

Below right: The detail of the Bishophill Junior tower, a rare survival and a fascinating building.

the city, and was retained in the 'unintelligent and destructive restoration' (*Ecclesiologist*, 1861) in 1860 that resulted in the simple Victorian limewashed interior we see today that seems to obscure the churches' great antiquity.

The location of the church is also interesting and its proximity to Holy Trinity could well signify an earlier structure of some significance. The finding of a Roman fountain nearby, and the unusual curve of the street around the plot, all combine to add to the interest of this building.

Archaeological work undertaken behind the church found the foundations of a Roman building with an apsidal end, its floor covered in fish scales that were left by later occupants.

What these finds signify is hard to say but the church, along with its sister church of Bishophill Senior (unfortunately demolished in the 1960s) and Holy Trinity, all provide tantalising evidence of continued early occupation of this part of the city.

6. Treasurer's House (Twelfth Century Onwards)

Now one of the National Trust's flagship properties in the north of England, the Treasurer's House occupies a key location within the wider Minster precinct and reflects the status and importance of the one-time treasurers to the Minster.

The Roman Via Decuma, leading north out of the legionary fortress, can roughly still be traced along the eastern boundary of the Treasurer's House along the narrow cobbled street known as Chapter House Street. This route, also partially under the house itself and its associated northern gateway, appears to have been closed off in the early medieval period and resulted in the preservation of this street on its original alignment. This action, which may have been to somehow secure the early religious precinct, resulted in the development of nearby Goodramgate as the main thoroughfare through the city to the north, conveniently and, perhaps significantly, outside of the ancient fortress wall.

The first Treasurer of York was appointed by Thomas of Bayeux, the first archbishop of the city and Royal Chaplain to William the Conqueror in the eleventh century. Thomas himself likely lived on, or very near to, the present site.

De Gray's court to the rear, which once formed part of the treasurer's lodgings, still contains the twelfth-century wall facing the internal courtyard.

In 1547, the house was reputedly in poor condition and this began a series of modifications and improvements. As a result there is little left to see of the original buildings and much of the house today is the product of seventeenth- and nineteenth-century changes.

Frank Green, an eminent Arts and Crafts enthusiast and wealthy industrialist, undertook perhaps the most dramatic alterations when he employed the architect Temple Moore to open up the house, in order to form a great hall, in 1900. He subsequently began importing architectural features from elsewhere and, in order to accomplish his vision, he had to radically remove a whole ceiling, among other things! This created a rather disingenuous whole and inevitably makes life much harder for the later historian of ancient buildings. Nevertheless, the building epitomises the reuse, remodelling and constant habitation for 800 years and does still contain a well-preserved seventeenth-century staircase and several fireplaces.

Any tale of the Treasurer's House is incomplete, however, without a mention of its most famous story. In the 1950s, a workman named Harry Martindale was working in the

Left: The Dutch-style gables of the Treasurer's House. This section is largely seventeenth century and forms the dining room elevation.

Below: The seventeenth-century main entrance opens into the Great Hall of Frank Green's house.

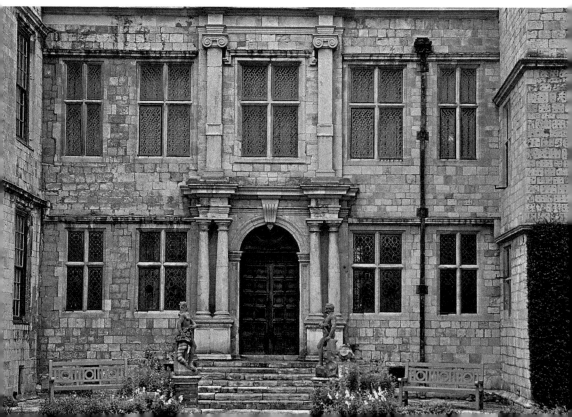

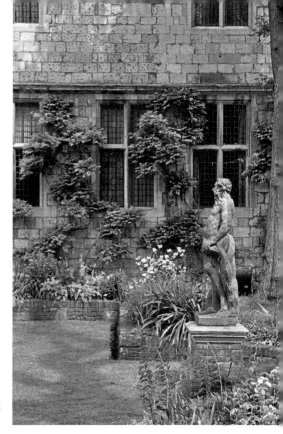

The beautiful gardens, meticulously maintained as always by the National Trust.

house's cellar when he heard the footsteps of a ghost legion. Turning to look, he then reports to have seen the soldiers themselves, their feet slightly submerged beneath the cellar floor firmly planted on the Roman levels. National Trust tours and special exhibitions now relate this story as well as explaining the Roman context upon which the house now stands and the tale even has a beer named after it – a suitably dark porter brewed by the York Brewery.

Today The National Trust, as one would expect, present the furnishings and collections of Frank Green in their best light and are constantly improving the visitor experience, most recently with the cellar conversion to create a publicly accessibly café … Roman sides optional!

7. St Olave's Church, Marygate (Eleventh to Nineteenth Century)

Of all the churches in York, St Olave's is one of the earliest parish church foundations and, although precious little fabric remains from the original Anglo-Saxon building, the nave still relates the early Anglian religion in York.

The church is late Gothic, but was heavily restored in the eighteenth century following, like so many buildings in this part of the city, damage in the Civil War siege of York in 1644, when the Parliamentarians laid siege to the city, and it was in the vicinity of Marygate that the city walls were undermined and a charge was set off to gain entrance into the King's Manor.

According to the York historian Francis Drake, the tower of St Olave's was also used as a gun platform. Whether this was true or not, the fact remains that the churches of York

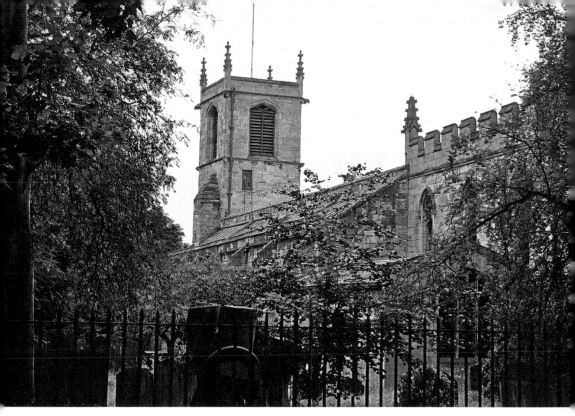

St Olave's Church, badly damaged in the Civil War but representing one of the earliest foundations in the city.

provided convenient lookouts and were often strategically placed, and, like the church of St Lawrence at the opposite site of the city, St Olave's suffered great damage.

Today the church sits on the quiet, almost suburban, street of Marygate and backs onto the nave of St Mary's Abbey ruins that neatly form the rear boundary to the churchyard.

The church and its churchyard represent a piece of calm in the city and presents a feeling of careful custodianship and antiquity, with its ancient gravestones beneath the cooling mottled light of overhanging trees and moss-covered limestone.

8. Clifford's Tower/York Castle (Eleventh century)

One of the strange things experienced by visitors to York is the perceived lack of a quintessentially grand-looking castle for such a historic town. It would appear to be a major omission, until they scratch the surface of Clifford's Tower and soon realise that what they are looking at is essentially a Norman motte-and-bailey castle. Perhaps the fact that it is surrounded by a sea of car parking leads to this misconception?

York actually had two castles, three if you include the Roman fortress and, arguably, four if we add the Civil War defences on The Mount that have now long since disappeared beneath Georgian villas.

The sister castle of Clifford's Tower was on the south side of the Ouse behind the city walls, now called Baille Hill, and both were constructed by William the Conqueror to protect the city from invasion along the river, as well as making his presence felt upon

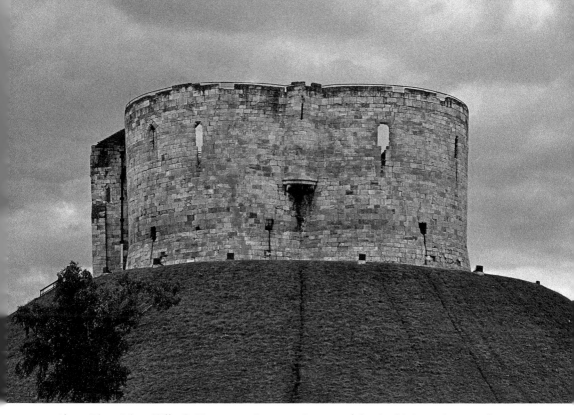

Above: The mighty Clifford's Tower atop its motte. Just out of shot in this image is a sea of car parking that, although useful, is a wasted opportunity for quality public realm!

Below: The precarious situation of what appears a heavy structure upon the motte but a classic view. A similar view was painted by the artist L. S. Lowry.

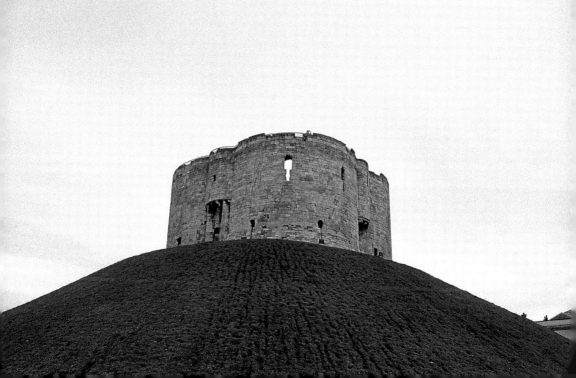

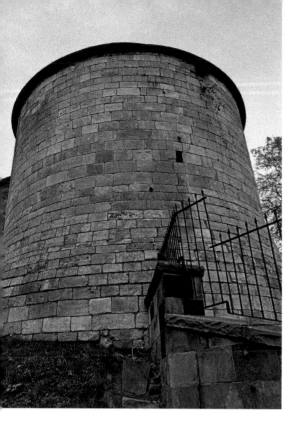

The remains of the castle defensive walls still performed a function – to keep prisoners in the Debtors' Prison that stands immediately behind this tower.

the city. The population immediately rebelled, which led to the ultimate burning of the city in retribution and was instrumental in leading to the Harrying of the North that was masterminded from York.

Baille Hill was subsequently left to become overgrown, but the continued use of York Castle as a fortress and prison for almost 1,000 years has meant that around Clifford's Tower there existed, until recently, what was in effect a self-contained citadel within the city.

The castle occupied a huge area and the whole south-east of the fortress was essentially a kind of militarised zone for much of its history.

On construction, the Foss was dammed so as to create the King's Fishpond that provided a northern water defence, and to the east the city walls provided a robust defence to the Ouse and beyond.

Clifford's Tower itself is one of the icons of York, perched precariously upon its mount. The present building dates from the thirteenth century and is a very rare survival of the period. Its predecessor was burned down in a now infamous and tragic episode in which the town's Jewish population were massacred.

The new castle was likely designed by Henry of Reyns, Master Mason of Westminster Abbey, and takes much of its inspiration from French castles of the time with its rotund form and central gatehouse.

The name Clifford's Tower has vague origins, but two theories by English Heritage suggest that the name may have come about due to the hanging of the rebel Roger de Clifford, whose body was displayed on the tower after his execution in 1322 following the battle of Boroughbridge.

The tower finally saw action, as it were, in the Civil War siege of York in 1644. Like so many strategic points in the defensive ring of York, the castle was a prime target; but the fighting

was more concentrated around Bootham and Walmgate. Nevertheless, the castle was used as a Royalist stronghold and was repaired accordingly just prior to the Civil War in preparation.

The castle's fortunes waxed and waned after this and it eventually fell into further disrepair. On the construction of the York Prison, which formed a central prison block with wings extending in all directions in the former bailey, Clifford's Tower was maintained on its motte as a kind of folly, inaccessible and merely left by the authorities as an incidental old building.

Its rescue came in 1902 when Mr Basil Mott undertook investigations into the stability of the mound that ultimately led to the ownership by English Heritage. Most recently English Heritage have been attempting to improve the visitor experience of the tower by the building of a new visitor centre that, controversially, would be built partially within the motte itself.

This plan for a simple stone-clad building has experienced serious local opposition, which is unfortunate. However, the main problem for the future of the tower is its setting. Surrounded by car parking, with no sense of quality space around it, the scene really is something that needs improving and making public once and for all, as without this investment the city is failing itself in its duty to celebrate a key part of its townscape.

9. The Norman House, Behind No. 48 Stonegate (Twelfth Century)

The Norman House is a classic example of early structures being either amalgamated into later buildings or forgotten about, as the principal frontage rooms are modified and changed to present a more modern appearance to the street, the rear rooms then becoming ancillary and used perhaps only for storage. It appears that this was indeed the case here

A view of the remains of the so-called Norman House, its mullion window providing fascinating evidence of early stone house construction in the city.

Likely a simple stone structure, the Norman House was forgotten about as later modifications took place around it. It was only rediscovered in the 1930s.

and this fragment of building takes on a whole new significance when we remember that it predates all of the other timber-framed buildings that we know of in York.

The so-called Norman House has been a ruin of considerable study and falls into the category of the earliest stone houses in the country, dating to around 1170. Stone houses of this type are extremely rare and represent very high-status buildings. The best-known example is the so-called 'Jew's House' in Lincoln, which also dates to the twelfth century.

The building was part of the estate of York Minster and the present ruins were only discovered upon demolition of later buildings in 1939. Ever since then, the remaining two walls have been preserved and made more comprehensible by the two-light arched window that survives to the first floor.

To add to the significance of this building, the remains of a garderobe shaft were found during excavation in 1939. This in itself is a very rare find of high-status architecture and may reflect the technological advancement brought to the Minster by masons and builders, many of whom migrated to the city from France as masters of their art. Such devices of architectural sophistication were just one of the contributions they made to the fabric of the city.

10. St Mary's Abbey (Thirteenth Century)

The Abbey of St Mary was, in its heyday, the largest religious building in England. It occupied a site immediately to the west of the Roman legionary fortress in an area that may well have sported a military annexe at some point in the Roman period.

The abbey precinct was vast and covered all the way from the river, around the outer fortress wall and up to Bootham, and represented one of several major religious centres in the medieval city.

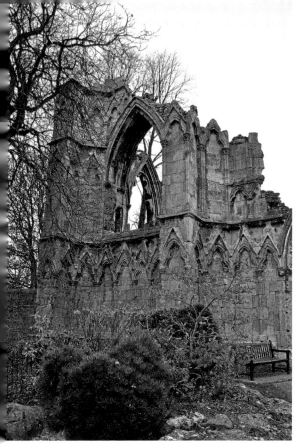

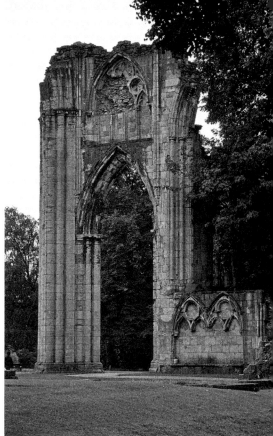

Above left: The remains of the west end of St Mary's Abbey, now a romantic ruin in the Museum Gardens.

Above right: St Mary's matched the grandeur and scale of York Minster and this photograph gives us a glimpse of what this former scale would have been like.

Right: Details of the internal piers with the nave behind.

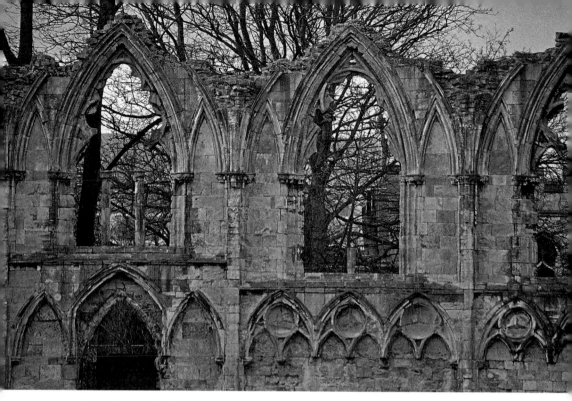

The northern wall of the former nave is often the stage backdrop to the York Mystery Plays. Now the bare winter branches echo the former tracery that once filled the windows.

The King's Manor was part of the precinct and was the location of the Abbott's lodgings.

St Mary's itself was founded in 1088, by William Rufus, as a Benedictine house and had such wealth and power that it ultimately became a prime target for Henry VIII. The remains are mainly thirteenth century and what remains of the nave exudes medieval Gothic architecture at its best – this is despite its remains being used as a convenient quarry to build the Debtors' Prison in the early thirteenth century.

Rich tracery can still be seen in the windows abutting the churchyard of St Olave's and the whole place is still a classic example of the Romantic period's obsession with the noble, picturesque ruins majestically placed within a pristine English garden that today survive as the Museum Gardens. Even now the York Mystery Plays use the ruins as a dramatic backdrop to their biblical tales and such use reflects the plays' medieval origins.

There are other buildings within the precinct that still survive, not least the perimeter walls and turrets that run almost the entire circumference of the site. Marygate itself formed the 'extramural' settlement outside the walls of the abbey and when the visitor passes through the thirteenth-century gatehouse, just to the south of St Olave's Church, they are once again back in York, but this time on the quieter, more serene and residential side of the city.

11. Walmgate Bar (Twelfth Century)

Walmgate Bar often seems to have been forgotten about, standing as it does at the far eastern extremity of the city walls. Indeed, it is partially for this reason that the bar itself is the only gateway left in the city to still have its external barbican. Once every gate in the city

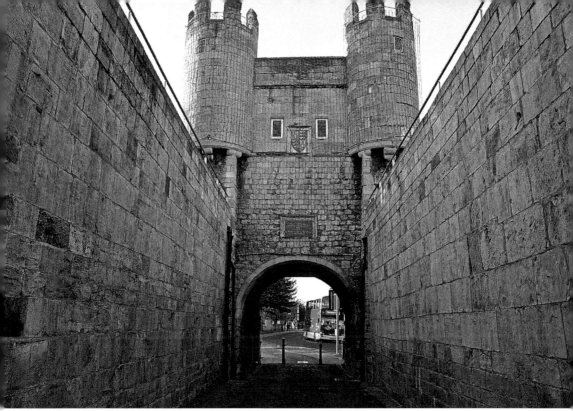

Above: In the killing zone: the last remaining barbican in the City of York at Walmgate Bar.

Right: The later sixteenth-century additions and modifications safe in the shadow of the medieval gateway.

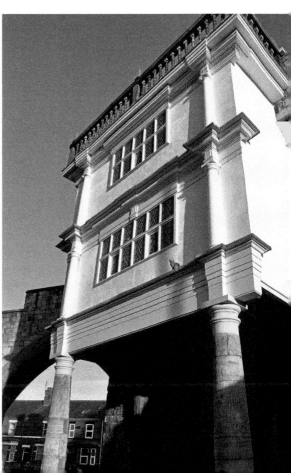

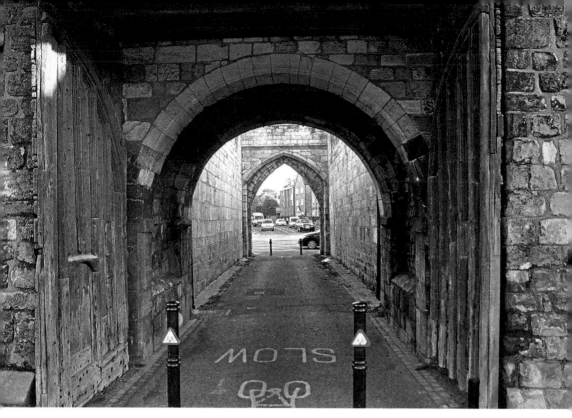

Beyond the gateway was once the market of Lawrence Street but now the barrier between the two is the York inner ring road that although diluted in its original design, still creates a harsh environment for those on foot.

had this medieval anti chamber with double portcullis and tower, but most were removed in the eighteenth and nineteenth centuries. Walmgate however, despite the unfortunate proximity of the York ring road immediately outside, still retains a strong character and once inside the feeling of being shut within still, just about, endures.

The bar consists of a twelfth-century archway, fourteenth-century Barbican and a later sixteenth-century timber room to the rear. This transition is curious and shows on the one hand the harsh, defensive nature of the walls, but on the other the domestication and reuse of these buildings in later centuries. It was also on the frontline of the English Civil War siege and was heavily shelled from nearby Lamel Hill near St Lawrence's Church.

Walmgate itself was the main approach from Hull and, immediately outside the wide marketplace, must have been a bustling place with traders loitering beneath the steel grey of the walls that accommodated this area from the twelfth century; but due to plague, fire and economic downturn, the area never really fully developed until later in the medieval period.

Although Walmgate sported medieval frontage buildings, some of which remain, there was still plenty of space to the north and south. This land was soon taken up, however, in the nineteenth-century expansion of the city, and this area was a focus for Seebohm Rowntree's book on *Poverty* that demonstrated that it wasn't just the large cities that suffered destitution and pestilence, but also the provincial towns. As a consequence of this, large areas of housing were demolished and replaced with later twentieth-century social housing, but the bar still stood ever strong nearby.

In 2016 a major restoration took place that found some scary structural defects caused by rotten timbers, but fortunately now the building is strong enough to withstand a hit from a passing car – not that this should be necessary and perhaps one day the building will have the surroundings it deserves. Until then it is certainly worth a visit to the rooftop café where visitors can pretend to be king of the castle.

12. King's Manor (Thirteenth Century)

The King's Manor, now home to the University of York's archaeology department, originally dates to the thirteenth century, when it was part of the complex of St Mary's Abbey and formed part of Simon de Warwick's Abbott's lodgings.

Assessment by the Royal Commission suggested that the house was likely U-shaped due to the remnants of older material still located within the walls, most notably architectural mouldings from column plinth. The buildings were heavily modified in the fifteenth century, when the ranges were reconstructed using extensive brick.

Following the surrender of St Mary's during the Dissolution of the Monasteries, the site became home to the Council of the North, who had devolved authority in general and political affairs. This was an era where the lawyers and civil servants must have given York a comparable feel to that of Whitehall and reinforced York as a true second city.

In 1541, Henry VIII himself visited York in the company of Katherine Howard and stayed here for nearly a fortnight, prior to which over £800 was spent on 'repairing and

A view of King's Manor from Museum Gardens, once the Abbott's lodgings of St Mary's.

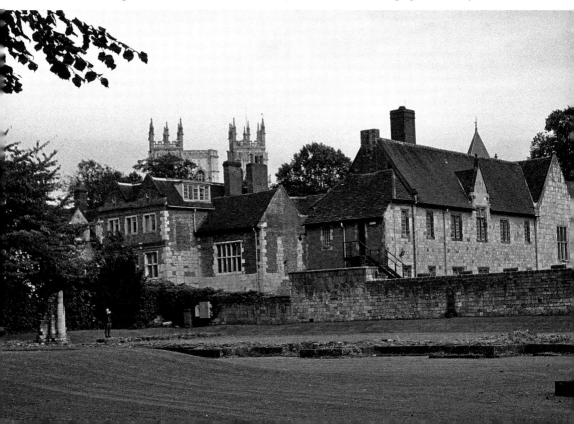

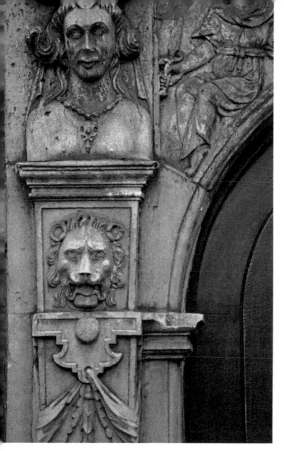

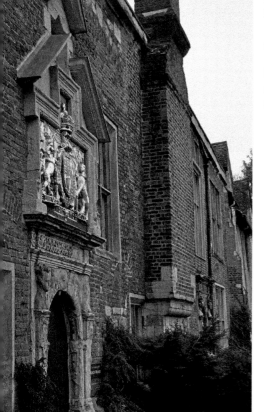

Above left: Detail of the main entrance to King's Manor.

Above right: Details of the coat of arms of Charles I.

Left: A view along the front of King's Manor showing the elaborate doorway in context. Note the typically Tudor chimney towering above.

beautifying' the complex in preparation for his visit. The manor's fortunes continued an erratic course following this and nearly suffered demolition in 1550 when it is recorded that 'such spoyle and defacing made in divers parts of his highnes said palace, that hit wold greve any man to see it'. (Talbot papers b 216 RCHME)

Following this dip in fortunes the manor was further extended in the later sixteenth century leading to the form we see today, with new cross wings and a further courtyard to the rear in order to literally build a palace fit for a queen in preparation for a visit by Elizabeth I. So lavish was this palace to be that in 1569, following a request for a further 100 oaks, the surveyor of the fabric was told that the queen 'Layeth away her owne Buildings by reason of the grate charges' and would not agree to further expense being paid to her accommodation at York.

The buildings, all simply rectangular in plan, with brick, stone and pantiles, form a series of quadrangles as one moves through the spaces. Starting at the left-hand side doorway the coat of arms of Charles I greets the visitor and the rest of the building feels like a private manor, except without the lavish furniture or decoration of a place that is lived in. There are numerous fine renaissance and Elizabethan fireplaces and the odd random piece of timber or carved stone. Much of what we see is from the sixteenth and seventeenth centuries.

A new range of buildings was added in 1900 to the front, but in a seventeenth-century pastiche style, which is a remarkable achievement in respecting context and, although it fails to break any new ground architecturally, it was a very 'safe' option and very well executed. This can't be said for the 1963 Fielden and Mawson range to the very rear of the site that evolves the site with a truly brutalist insertion. At first, to the visitor this range appears a bit of a disappointment and can't compete with the ancient fabric of the older buildings; but on closer inspection, it is actually an interesting lesson in how to respond to an historic architectural context.

Constructed upon sixteenth-century stone vaulted cellars, the new structure respects the proportions and footprint of the older buildings, but unashamedly uses concrete and large expanses of glass to give a suitably modern aesthetic. This works to some extent and it is a valuable lesson in the evolution of an historic site for modern needs.

13. Hospitium, Museum Gardens (Fourteenth Century)

The Hospitium of St Mary's Abbey now stands isolated from the rest of the abbey precinct and this may lend credence to its history as a lodging for visitors, although the Royal Commission suggest that the lower storey was used as a tailors' workshop for the abbey.

The hospitium would, however, be in the right place for a lodging house and is similar to that of Kirkstall in Leeds, where the visitors to the abbey were lodged to the west in front of the main nave entrance and out of the way of the cloisters.

The building itself dates to the fourteenth century with the upper storey slightly later. Downstairs the stone walls were likely of such solid material to withstand frequent flooding, although historically there was a separate boundary wall running alongside the river, so floods may not have been as much of a problem as they are now.

Following the dissolution, the hospitium seems to have been retained as a farmhouse, or other ancillary building, until it fell into a more ruinous condition.

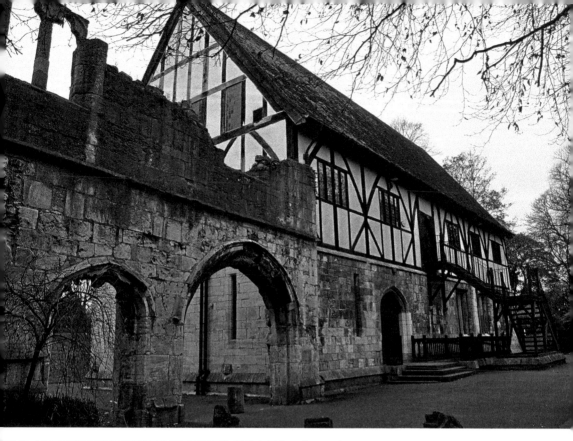

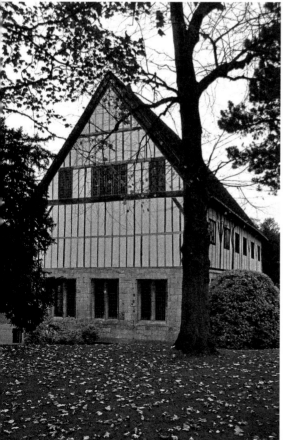

Above: The Hospitium was once part of a wider complex of ancillary buildings to St Mary's Abbey, but these walls are all that remain.

Left: The west elevation of the Hospitium, another romantic medieval building, now used extensively for fairy-tale weddings.

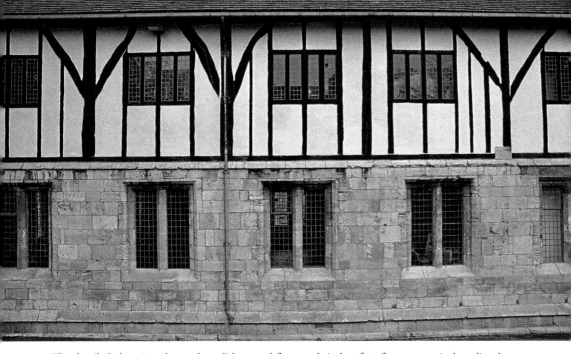

The detailed elevation shows the solid ground floor and timber first floor – a typical medieval construction.

The York Philosophical Society subsequently restored the building in order to house and display artefacts from the site and city, and the timber-framed upper floor also had its roof heightened in the 1930s, presumably to enable a greater use of the building.

The hospitium now stands majestically within the beautiful Museum Gardens, the landscape of which epitomises the Romantic period, and the building is booked out most weekends for weddings, where the simple limestone of the ground floor provides a fittingly magical place complete with all the modern facilities needed for such events upstairs.

14. Our Lady Row, Nos 64–72 Goodramgate (1316)

This modest little row of cottages backs onto the graveyard of Holy Trinity and represents some of the earliest surviving urban houses in England.

Dating from 1316/17, the buildings are timber framed and rendered with later brick infilling as modifications have taken place over their 700 years. The York architectural historian Dr Gee felt that the front overhang, which was later to become such a common feature of higher medieval urban buildings in the city, was the earliest of its kind in the country.

Originally without staircases, the upstairs rooms were likely reached by a ladder in the rear corner of each unit, as there is no evidence for internal stairs. Their low eaves and high-pitched roof are now commonplace as part of the medieval townscape, but lack of standard maintenance to some of the properties, probably in the form of cement-based render, has recently caused parts of the original timber frame to rot.

The near collapse of the corner of one building in 2016 was likely caused by water ingress combined with poor modern materials totally unsuitable for a medieval structure.

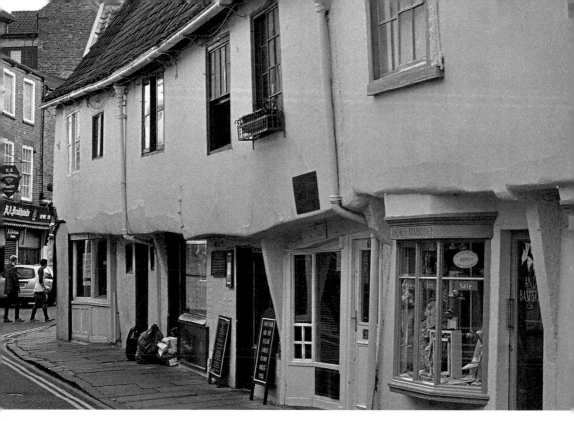

Above: The wavering form of Our Lady Row, Goodramgate, reputedly the first time a first-floor jetty was used.

Left: A detail of the Yorkshire sliding sash windows, a variety of which can still be found in these buildings. Behind the render is a simple timber frame and thick lathe and plaster.

15. Holy Trinity, Goodramgate (Fourteenth to Eighteenth Century)

Holy Trinity is tucked away behind the ancient fourteenth-century houses of Our Lady Row, which were built on part of the former graveyard of the church in order to provide accommodation for the church's priests. Now, under the careful custodianship of the Churches Conservation Trust, the building is a remarkable survival, not least due to its magnificent eighteenth-century box pews that escaped the Victorian improvers' attempts at modernisation.

The floor in the nave almost waves and undulates as it is so twisted with age, and the pews seem to follow, their ancient panelling bending and warping in consort. This may be in part due to the raising of the floor level in 1633 that followed extensive building work throughout the fifteenth century.

The church was likely founded in the twelfth century, although there are only two extant pieces of twelfth-century masonry left near the altar. The side chapels are also worth attention as they contain carved motifs very similar to those of All Saints, North Street, which suggests the same workmen were responsible for both in the medieval era.

The graveyard, standing beneath the towering Minster, is entered either along the long passage from High Petergate or through the eighteenth-century brick archway from Goodramgate. In 1905, this archway sported a neatly written sign: 'Offerings towards repairs earnestly asked for.' Since then the Churches Conservation Trust has maintained and helped stabilise the building and as a result the sense of travelling back in time is preserved.

The church is most certainly a must to visit, not only for the peace and serenity it provides, but also on those carol service days where candlelight is still the only illumination, the church never having had any electricity.

The undulating aisle of Holy Trinity, Goodramgate, complete with its box pews that are unique in York.

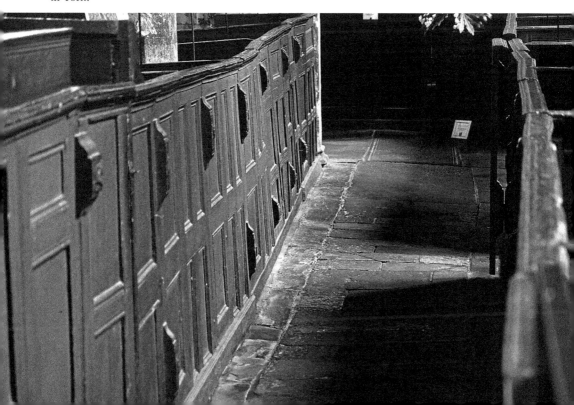

Above left: St George and Dragon filters the light into this beautiful church.

Above right: Candles are the only artificial light within the building and carol services are still conducted by candlelight.

16. Merchant Adventurers' Hall, Fossgate (1357)

The Merchant Adventures' Hall is one of the oldest buildings in England, and by far the best medieval secular building in York. The hall is the result of the careful custodianship of the Merchant Adventurer's Company for over 600 years. A unique institution in its own right, this was the building that oversaw trade between York and the world and welcomed its fair share of merchants and wealthy patrons of trade through its doors.

The building exudes a rich and highly significant history and sense of place. Its gnarly, silvered timbers still welded together through the use of pegs and tenon joints even now create a magnificent spectacle. The main hall itself is tucked away off Fossgate behind two almost as old timber-framed gabled buildings that contain some of York's most charming independent cafés.

The best entrance is beneath the gold coat of arms and through the pedestrian tunnel, which emerges in front of the main entrance, flanked by the oak pilasters and lions' heads that were part of this sixteenth-century addition.

The hall is still home to the Merchant Adventurers (still represented by traders with interests in the city) but is also used for a variety of other functions, most notably weddings … and what a venue it is. The towering double nave exposes the fourteenth-century roof structure, its floorboards, sloping and wonderfully warped beneath the rich and colourful

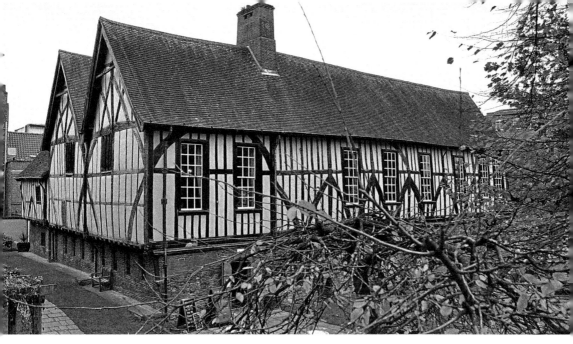

Above: The grandest of all medieval halls: the Merchant Adventurer's Hall.

Below left: The double Pegasus coat of arms of the company welcomes visitors from Fossgate and directs them under the brick tunnel before emerging at the sixteenth-century lion heads flanking the entrance.

Below right: The carved-oak lion heads atop oak pilasters mark the entrance.

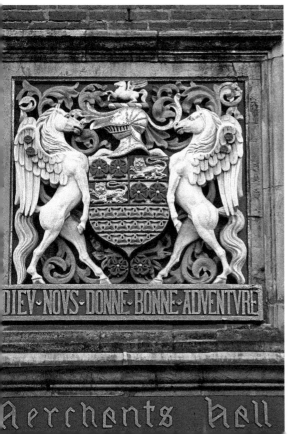

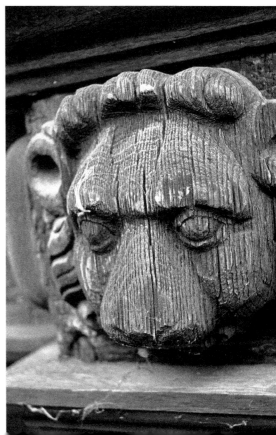

The outside lantern with timber gables behind.

portraits of Merchant Adventurers past, gazing down from the walls from their gilt frames, wearing everything from Elizabethan neck ruffs to modern suits.

The materials to construct the hall are still recorded: 100 oaks were bought from nearby Thorpe Underwood and 20,000 bricks from the York Carmelite Friars. Beneath the hall is the stone-flagged undercroft, showing off the piers that support the timbers above, and the seventeenth-century chapel provides yet another phase of development and modification that tells the story of this place.

The chapel, first consecrated in 1411, now sports seventeenth-century green panels, pews and stalls. The undercroft was once used as a gunpowder magazine and a makeshift prison in the Civil War that ravaged York in 1644. Most recently the whole floor was underwater as the 2015 floods seeped in from the nearby River Foss.

17. 'House of the Trembling Madness', No. 48 Stonegate (Fourteenth Century)

Stonegate, literally meaning the 'stone-paved street', formed the main approach through the Roman legionary fortress from the southern gate and ran directly towards the centrally located Headquarters building. Ever since, this street has been the direct route towards the Minster and the religious foundations within the walled enclosure of the city.

There are a huge amount of medieval buildings lining Stonegate at both sides and, since pedestrianisation in 1974, the street has been a major destination for tourists and residents alike, and the street now sports a wealth of prestigious shops. New uses emerge as time allows and, until recently, one of the lesser-known bars in the city occupied the upper floor

of No. 48. On entering this unassuming Victorian-fronted building the visitor enters a shop filled with beer bottles for sale. It is an off-licence selling all manner of drinks and craft ales.

However, to the upper floor and rear of the building is a remarkable space that is now a bar. Nominated CAMRA city pub of the year in 2015, 'The House of the Trembling Madness' is a friendly establishment that occupies what was once a real-life medieval open hall of the fourteenth century and backs directly onto the oldest stone house in York, the Norman House.

The lofty space has been altered over the years, but the structural timbers suggest a roof capable of spanning over 6 metres. The later additions can also be comprehended, as the solid limestone wall on the rear elevation has clearly been chiselled out to create the tenuous line of a brick chimney, probably in the late seventeenth century.

This building, whatever its future use will be, not only equips the visitor with the means to appreciate the phasing of a building that has seen near continuous use for over 1,000 years, but also allows them to see both the solidity and the fragility of the history of this city.

18. St William's College, College Street (1465)

St William's College was built in 1465 in order to provide accommodation for twenty-four fellows and priests serving the Minster chantries. It is a beautiful and important court-yarded building, with a stone ground floor and jettied timber rooms above. It is,

The first-floor elevation of St William's College.

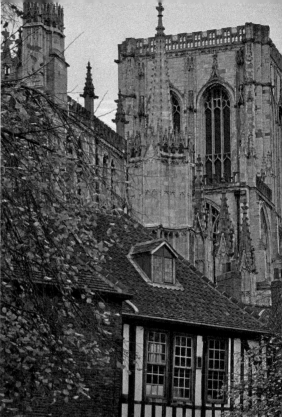

Above left: The insertion of later Georgian bow windows changed the character of the college building but enabled its reuse.

Above right: A rear view of St William's from Ogleforth with the Minster's central tower dominating the view.

perhaps, one of the most striking medieval buildings in York, and although the original room layout is near impossible to determine now, the visitor is rewarded on its open days or Christmas fayres with an experience rarely had in many towns, as the ancient floor creaks beneath one's feet and the timber trusses reach skyward above.

The frontage now contains Georgian bowed shop windows inserted into the fifteenth-century stonework and the main entrance for visitors is now from College Street, over which towers the Minster's recently restored East End.

The visitor then continues over the courtyard and into the north range, where the original medieval hall is likely to have been. It has been proposed that the courtyard itself, surrounded on all sides with rich limestone and protruding oriel windows, resembled the Oxford and Cambridge colleges with each doorway sporting its own staircase, but specific evidence for this is still lacking.

Nevertheless, the survival of St William's is equally important to those of the medieval colleges of Oxbridge and its importance cannot be overemphasised.

Following the dissolution, the college had several owners and many alterations were made, most notably the insertion of new chimneys and the blocking of doorways and windows.

The Earl of Carlisle lived here until his grand house, Castle Howard (near Malton) was finished. The college was finally bought by the saviour of the nearby Treasurer's House,

Mr Frank Green, whose architect, Temple Moore, carried out further modifications and used much artistic licence in his restorations. Frank Green subsequently sold it once again to the church authorities, under whose ownership it still belongs.

19. Guildhall (Fifteenth Century)

The civic hall in York was first mentioned in 1256, where it was known as the 'Common Hall' and was situated more or less on the same site. Common Hall Lane still runs under the present Guildhall building leading to the waterfront staith and blocked entrances once led to cellars underneath the building. The nearby Mansion House replaced the outer gate of the precinct that was still known in 1726 as Common Hall Gates.

The present building was constructed in the fifteenth century and used stone obtained from Tadcaster (where the best limestone, since Roman times, was to be found).

The hall originally still maintained the traditional medieval layout with central hearth, dais and screens passage at the east end. This would very soon be an outdated method of layout for such halls and has its origins in the early medieval and Anglo-Saxon period, where halls with central hearths were the norm.

The building had a plethora of other ancillary buildings around it but none of these now remain. However, committee rooms to the rear on the riverfront still exist, where council planning meetings were held up until recently.

Tragedy came when the hall itself was devastated by the Luftwaffe's Baedeker Raid in 1942, when the Guildhall and nearby St Martin's Church were badly damaged.

The Guildhall from the Ouse with the main hall to the centre with Gothic pointed window.

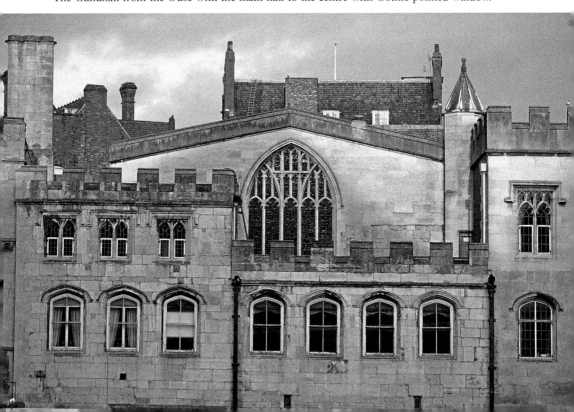

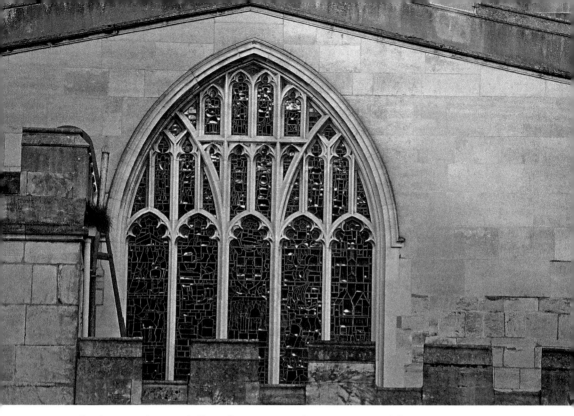

The glazing in the main hall window was specially commissioned following restoration.

The empty shell of the building, gutted by fire, was to remain in such a sorry state for eighteen years. Eventually the great estates of Yorkshire contributed appropriate structural oaks and the hall was lovingly and accurately restored, using, as close as possible, the same skills and medieval building processes. The result is a new perpendicular Gothic hall, its giant oak pillars still supported on original stone bases and new, wonderfully coloured glass that filters the evening sun through the west window.

The hall is still used for fayres, events and functions but the council meetings now take place in the later Victorian chamber of 1891, where plush leather seats are tiered around in solid-oak rails and benches, a suitably neo-Gothic response to its historic neighbour.

20. No. 35 Stonegate (Fifteenth Century)

This former medieval house is now one of those reasons why historic buildings are irreplaceable and entice so much enthusiasm from visitors.

Now a retail shop, this three-storey, jettied, gable-fronted building dates to the fifteenth century and oozes charm, character and a sense of history that is absolutely unique. Currently occupied by the Oliver Bonas chain of shops, the custodianship of this building is second to none and the building can be experienced even though it now performs a completely different function to the one it once did.

The house has, like many buildings on Stonegate, a mixed, ancient and varied vintage with fifteenth-century timber framing, a seventeenth-century rear range and an eighteenth-century dividing extension. However, what makes this building really special are the rooms and

Right: No. 35 Stonegate, its towering jettied gables so typical of Stonegate.

Below: This was once the shop of Francis Hildyard, York bookseller. Note the sign of the Bible above the doorway.

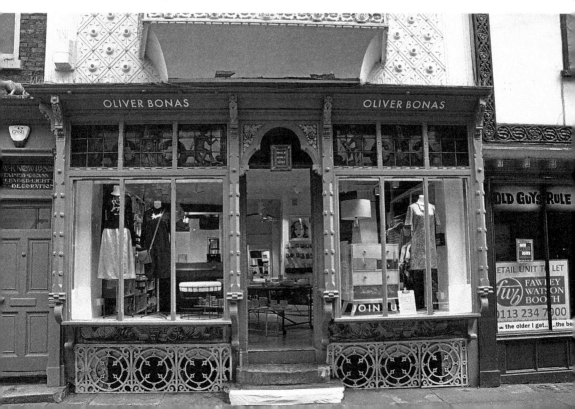

features within. On entering through the wonderfully decadent Georgian shopfront under the 'Sign of the Bible' we are remembering the use of this building as the bookshop of the same name, owned by Francis Hildyard, the man who re-released the updated Cossin's map in 1748.

Later the building became the house and workshop of the stained-glass artist J. W. Knowles and this suddenly explains the floor to ceiling coloured glazing that faces onto the old former passageway and courtyard.

Upstairs too, seventeenth-century oak panelling and original fireplaces certainly create something of a 'retail experience' like no other!

21. No. 51 Goodramgate (Late Fifteenth/Early Sixteenth Century)

This building is another hidden gem within the city along Goodramgate, a street that nicely skirts the edge of the old Roman fortress to link up with the northern gate to the city, Monk Bar.

Goodramgate has in recent years seemed a little tired, but the street has many fine fifteenth-century buildings, and this house is no exception. Indeed, although heavily restored, this timber-framed building is actually a 'Wealdon' type house that is more characteristic of early medieval country houses from the Home Counties and is rarely found within towns and cities. It is even rarer in the north of England, with only twenty examples in existence outside of Kent and Sussex.

The survival of this building does reflect the medieval practicality for urban residential halls to be at the rear of the main façade building and away from the street. They are rare, but can still be found hidden behind later additions to the street frontage.

No. 51 Goodramgate and the adjoining pub appear to have been interrelated and represent a rare 'Wealdon' type house.

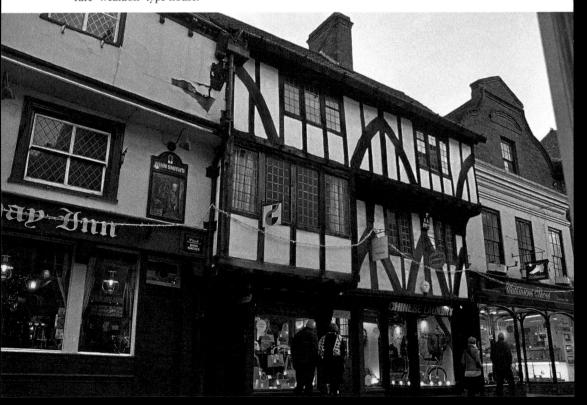

If the neighbouring record shop is open, it is possible to visit the side alleyway and see the classic Wealdon view, with double-height hall flanked by jettied rooms.

The building here exhibits all the elements of a Wealdon house; it has protruding jetties at either side of a central hall that rises to the whole height of the structure. Its windows are mullioned and, to the hall itself, there are large windows giving light into what could nowadays be a dark space due to so many surrounding buildings.

The side of the building can be seen by entering the alleyway to the 'Earworm' Record Shop, while the main building itself is now a shop called the 'Chinese Laundry' selling retro clothing and authentic vintage. The pub next door appears to have been part of the U-shaped complex too. The fact that the medieval hall still forms a backdrop is a particular bonus.

22. Ye Olde Starre Inne, No. 40 Stonegate (Sixteenth Century)

This famous pub on the York scene is reputed to be the oldest licensed premises in the city and makes claim to the fact that it has been that way since the reign of Henry VIII.

The pub sits off Stonegate and is certainly within one of the oldest parts of the city, with elements of the building dating to the sixteenth century, complete with moulded ceiling beams still visible on the ground floor.

The rambling rooms ensure seclusion and there is still a strong air of history about this pub, a theme that is intentionally exploited. This is enhanced by the many references to the building being used in the Civil War siege of York in 1644, when reputedly the wounded were treated in the basements.

Again, the building is in the right location to have been sufficiently behind the lines during the siege as most of the fighting took place in order to breach the walls around Bootham, the King's Manor and Walmgate. There is, however, a nice poem from the point of view of a Royalist soldier on the wall that does a lot to bring this rich history alive.

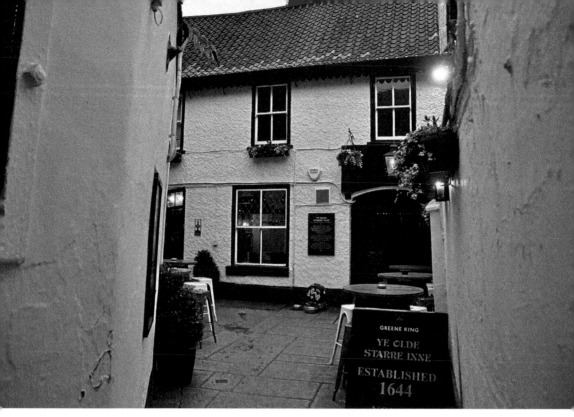

Above: Ye Olde Starre Inn can be found down the alleyway off Stonegate before emerging into the small courtyard seen here.

Below: The sign above the street dating from the eighteenth century.

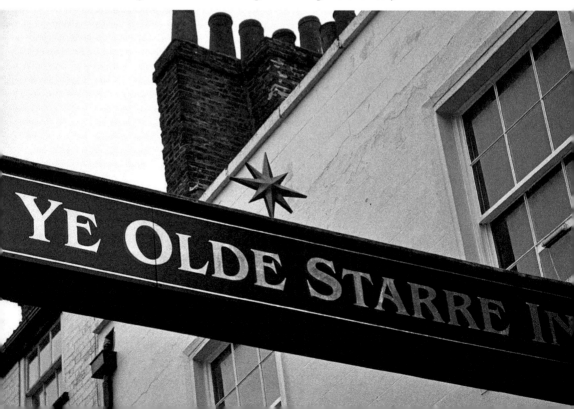

23. Jacob's Well, Trinity Lane (Sixteenth Century)

Jacob's Well is a fine, jettied, timber-framed medieval building with stone and brick ground floor, associated with the previous priory of Holy Trinity next door. It is unique because it sports a ground-floor hall – unusual as most medieval halls were on the first floor.

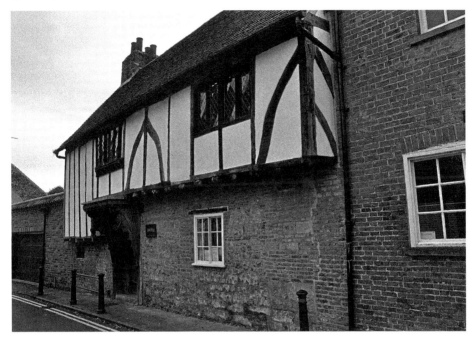

Above: Jacob's Well, once part of the nearby Holy Trinity Priory, then Hall, then pub and now a function venue again.

Right: The beautiful ornate carvings outside Jacob's Well.

The timber mullion windows are notable, as is the ornately carved timber canopy that came from the Old Wheatsheaf Inn in Davygate in 1907 when the building was used as a pub. There are possible earlier elements too, in the stonework to the lower walls, which may be related to even earlier structures that were part of the Holy Trinity Priory estate, and it is likely that the complex extended under the present rectory to the rear of the site.

Today the hall is used as parish hall for Holy Trinity and sports a variety of events. Its carved wooden brackets still stare outward at the visitor.

24. York Medical Society, No. 23 Stonegate (1590)

The York Medical Society has had connections to the medical profession in York since the early nineteenth century, when this amalgamation of ancient buildings provided accommodation for doctors, most notably Dr Tempest Anderson, whose black- and gold-lettered plaque is still in situ facing onto Stonegate.

Dr Anderson was a member of the Royal Society, an amateur photographer and a volcanologist, as well as being a well-respected ophthalmic surgeon working at York County Hospital.

The buildings themselves seem to represent an infilling of the rear yards of properties on Stonegate and Coffee Yard, and the main entranceway to the headquarters of the Medieval Society is through a very long, stone-lined alleyway that leads directly off the street and is usually gated.

The York Medical Society, once again reached along an alleyway away from the hustle and bustle of Stonegate.

Dr Anderson's plate still adorns the gatepost into the society's headquarters.

The buildings not only exude another wonderful example of various architectural phases, but also illustrate the peace and quiet that the traditional city can so often provide, and the gardens to the rear, overlooked by the large windows of the principal rooms, are an oasis of calm on a site that is pretty much the very centre of the city.

The house itself contains a core element of timber framing to its front and central ranges complete with later oak panelling. The structure was later modified and seventeenth- and nineteenth-century extensions protrude to the side and rear, including the large dining room to the south.

According to the Royal Commission survey, the oldest phases were actually structurally independent of each other and, probably, represent a joining of two separate buildings into one ownership.

The society is still very active and organises events and meetings throughout the year for its 350 members and the general public. It also sports a rare medical library that is now under the custodianship of the University of York.

25. Ingram Almshouses – Bootham (1635)

The Ingram Almshouses reflect the simplicity and functionality of the older vernacular forms of York but using more modern, seventeenth-century materials – in this case red brick and the newly fashionable Dutch gables to the sides. These, incidentally, reflect the predominant material of Sir Arthur Ingram's own home and estate buildings that he built at Temple Newsam near Leeds.

Above left: The almshouses directly abut the street but, behind, the units face onto a pleasant courtyard garden.

Above right: The Norman doorway, transferred to the building, certainly makes a statement onto Bootham with its distinctive chevron pattern.

The buildings almost look out of place among the larger, neoclassical Georgian houses that now surround them on Bootham, but this wasn't always the case and the almshouses were in the direct line of fire during the English Civil War when Sir Edward Montagu, 2nd Earl of Manchester, laid siege to the Royalist-held city and undermined and attacked the walls from Bootham in order to seize the King's Manor. This action resulted in significant, almost irreparable damage to the almshouses and records of the repair work undertaken in 1649 still survive.

The form of the almshouses is long, low and linear with a central tower feature and chapel behind. To the rear there is a wonderful courtyard garden so synonymous with the tradition of almshouses in the city.

The main doorway, facing Bootham, is clearly Norman and apparently comes from the ancient religious site of Holy Trinity in Micklegate. Why it is here is open to debate, but perhaps Sir Arthur's role in the Council of the North or as MP for York had something to do with it?

The buildings lent themselves conveniently to conversion as flats in the later twentieth century and, although most of the internal fittings were unfortunately removed in the 1950s, the buildings are now another wonderful success of the York Preservation Trust.

26. The Eagle and Child Pub, High Petergate (1640s)

High Petergate is another ancient street that more or less follows the line of the main east–west axis through the Roman fortress, the Via Principalis.

It stretches from Bootham, whose straight line is characteristically Roman, and leads towards Bootham Bar that is, in itself, approximately on the site of the ancient Roman gateway.

The street is narrow, full of charm, has a plethora of jettied timber-framed buildings and fanciful Georgian and Victorian bow-fronted shopfronts that lead, very slightly uphill, to the West Front of the Minster.

The Eagle and Child pub is a large, three-storey timber-framed building with protruding bay windows dating from 1640. Now under the custodianship of the Leeds Brewery, which has in recent years taken upon itself to undertake very good restorations of historic pubs, the building is yet another one of those rare, ancient structures that exudes a strong, almost inspirational, sense of history, and it is no coincidence that it is this pub that is the pub of choice for the archaeology students from nearby King's Manor.

The real experience is to be had on the upper floors where the eighteenth-century partitions still maintain the separate rooms, each individually snug with sloping, uneven floors that any self-respecting ancient pub requires.

On the attic level fans of modern history will be surprised to find the signatures of the Rolling Stones on the wall. The autographs, signed by all members of the original band (including Brian Jones), were written in bright-red lipstick. The significance of this is now reflected in the building's Grade II*-listed status.

The Eagle and Child on a cold winter's evening, its double gables glowing onto the street.

27. The Dutch House, Ogleforth (1648)

Ogleforth, although of lesser importance, is also one of the fossilised streets that reflect the Roman origins of the city and runs parallel to the city walls. Its name first occurs in 1109 and it seems to have been a street that skirted the Minster precinct. As such, ever since the opening up of College Street it has become rather secondary in its function, for visitors at least.

The Dutch House is one of the most interesting buildings on Ogleforth and is unique in the centre of York. It is a bit of an oddity in light of the fact that the house was not originally a Dutch house at all, as the rounded gabled dormers were slightly later than the original building. However, this takes nothing away from the building, which is constructed almost entirely from brick, with its variety of windows that sport their ornate architectural detail in the form of pediments and nice mullions all executed in the same material.

It may be possible that the house was intended as a showcase for this new material from the Low Countries. What is certain, however, is that the building is of exceptional importance, and this is reflected in its Grade II* listing.

The house is now a nice little holiday cottage within earshot of the Minster bells. It won a York Design Award for historic building conversion in 2010.

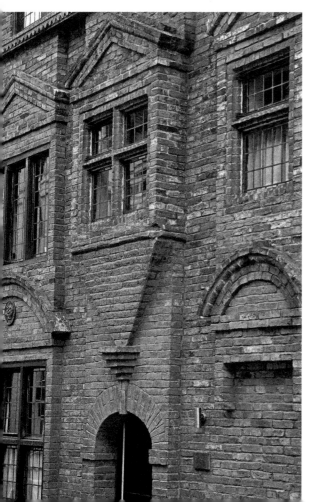

The Dutch House, reputedly the earliest completely brick building in York.

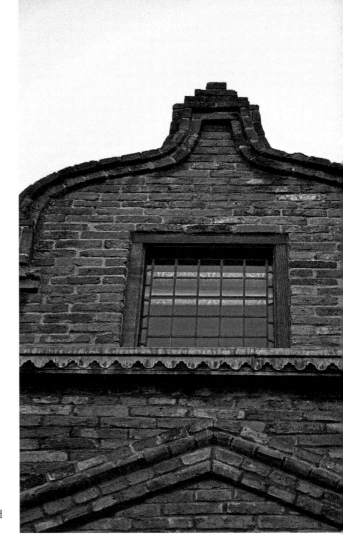

Detail of the odd mix of Flemish and classical details.

28. Unitarian Chapel, St Saviourgate (1689)

This is an interesting little building along St Saviourgate that still contains several hidden architectural gems of York, as well as retaining elements of the older residential city. The street was, until the formation of the Stonebow, a major thoroughfare in the city, but has now been almost relegated to a most underused street, which is unfortunate due to the grandeur of its architecture.

The Unitarian Chapel stands halfway along St Saviourgate within its own burial ground and is the oldest Nonconformist chapel in York. It was built just three years after the Act of Toleration of 1689 that allowed, for the first time, other religious denominations to practise in the city. The building was originally named Lady Hewley's Chapel after Lady Sarah Hewley, who contributed extensively to the fund for the building.

The chapel is unsurprisingly simple in form and is built in the form of a Greek cross with tower above the central crossing. The church was modified in the nineteenth century and this included the railings to the front; but the building retains the beautiful symmetry and simplicity that one would expect from the period.

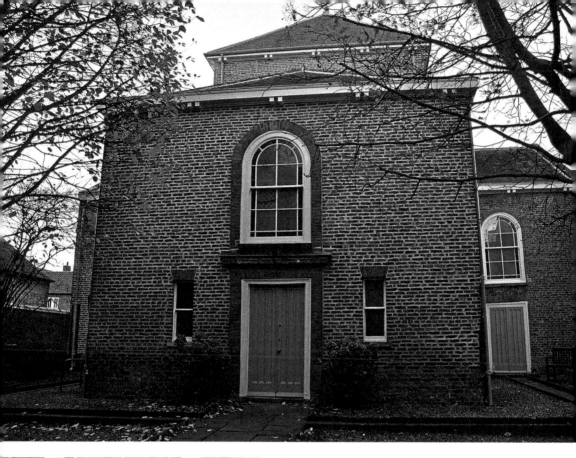

Above: The simple brick-built Unitarian Chapel: symmetry, simplicity and beauty together.

Left: Detail of the front doorway and main window of the chapel.

29. Debtors' Prison (1701–05)

Daniel Defoe described this monumental building as being 'The most stately and complete of any in the whole kingdom, if not Europe.' Francis Drake closely (perhaps too closely) echoed this sentiment by stating that the prison was 'A building so noble and compleat as exceeds all others of its kind in Britain, perhaps in Europe.' The Debtors' Prison was, indeed, at the time a groundbreaking building and was held up as a model of its kind, not only architecturally but also in the provision it made for prisoners – a far cry from the crumbling lodgings within the castle that it replaced.

Each cell measured between 8 feet by 7, with four rooms specifically for the condemned. The cells were further improved, through not only the removal of straw bedding off the floor, but also by having their own surgeon and an in-house infirmary.

The debtors, who represented a wide demographic of the population who had money troubles of all kinds (of which there must have been many in the eighteenth century), were housed in the upper storey but had the rights to wander freely about the castle grounds. Felons, on the other hand, were housed on the ground floor, along with four cells for the condemned; their exercise space was confined to the central area between the two wings that we see today, appropriately fenced off and facing north.

The building is U-shaped, with the castle walls – which still stand nearly at their full height – at the rear. It was here that the main entrance to the castle was historically located, immediately opposite Fishergate Postern and facing the opposite way to that of the city.

The grand classicism of John Carr in his Debtors' Prison, highly praised at the time as a model of its type.

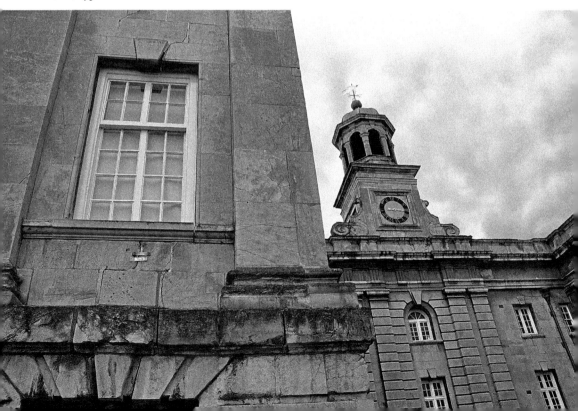

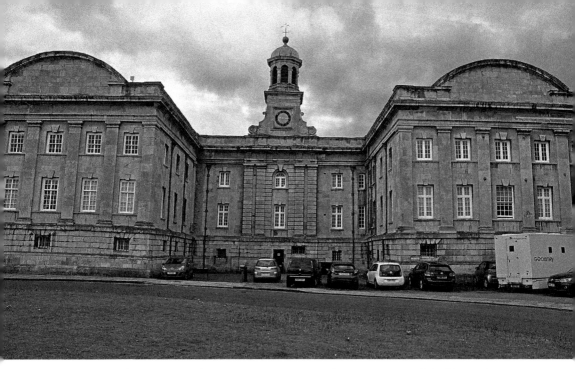

The central space, where the cars now are, was once the exercise area of the felons who were imprisoned here.

The construction of the building obtained much of its stone from St Mary's Abbey, as this site was fast becoming the quarry of choice for easy, good-quality building stone, but still required the permission of the king to take it. In this case, permission was given.

The prison's most famous resident was Dick Turpin and visitors can, even today, visit his cell, which is much unchanged. It comes complete with a projection of the man himself abusing the guards and protesting his innocence.

His protests were to no avail, however, and he was executed for horse theft on 7 April 1739 and ultimately became immortalised by the novelist William Harrison Ainsworth, who credited him with the famous 200-mile ride from London to York. In actual fact, it was the Yorkshire Highwayman 'Swift Nick' Nevison who achieved this feat in 1676. He was also hanged in York some eight years later.

The prison is today part of the York Castle Museum, but also houses the offices of the York Museum Trust, where staff now work behind desks in rooms that once housed prisoners and offered accommodation for gaolers.

30. The Judge's Lodging, No. 9 Lendal (1711)

Set back from the street, the Judge's Lodging (as it is now known) was built by the physician Dr Clifton Wintringham and is shown on Cossin's map of 1726 as the tall, symmetrical house it is, complete with swags above the door and trees in the front garden.

Francis Drake felt that this house was the 'pleasantest' and 'one of the best built houses in the city'. He goes on to say that 'This building, as it rose by giving health to numbers within the city and country, so may its wholesome situation add length to the days of the founder, and after prove … a lasting monument to his fame!'

The house was on the site of the former Church of St Wilfred that dated from the eleventh century but whose parish was amalgamated with that of St Michael le Belfrey in 1549.

In 1988, excavations by the York Archaeological Trust found two walls, believed to be the boundary walls of the churchyard of St Wilfred and, in 1994, burials were uncovered which add to Drake's description of the workmen finding 'cartloads of bones' on construction of the foundations for the house.

The house is a pleasant oddity within the city, mainly due to the fact that it is set so far back from Lendal itself, and this provides a little relief in the tightly packed streets of the central core.

The building is now a hotel, but the ornate plasterwork and friezes remain and are supplemented with modern décor; but the staircase, which even Pevsner described as beautiful, is restored in all its glory and makes the perfect ascent to the hotel rooms, many of which still maintain eighteenth-century plasterwork and have views of the Minster over the Assembly Rooms.

To the rear, the brave decision was taken in more recent years to create more rooms within the rear garden. Sunk down towards basement level, the contemporary rooms are minimal in nature and respond well to the context of the main house.

31. Red House, Duncombe Place (Early Eighteenth Century)

The Red House, whose name more than likely refers to the use of red brick in its construction rather than the stark render it is now painted in, was built in the early eighteenth century for the MP and Lord Mayor of York, Sir William Robinson, likely to

The Red House, with St Leonard's Place in the background showing the confidence of the Georgian era in the city.

the designs of William Etty. The site was once part of the York Mint (and, before that, part of St Leonard's Hospital), which was purchased for £800 from George Savile, Viscount Halifax, by the city authorities in 1675. The main reason for this purchase may have been to open out the city and link up to Bootham, but several lots were subsequently sold off for the construction of the York Theatre, St Leonard's Place and the Red House itself.

The house is neoclassical in style with five symmetrical bays flanked by white-painted quoins.

The building eventually came back into the council's custodianship and was used as part of the council's Leisure Services department. It was, however, subsequently bought by the York Preservation Trust and is now the Red House Antiques Centre, which allows visitors the chance to not only see inside one of York's most famous houses, but also to browse at everything from ancient Roman coins to grandfather clocks!

32. Mansion House (1724)

St Helen's Square was created in 1745 when the graveyard of St Helen's Church was paved over in order to improve the public realm of the now increasingly fashionable Georgian city.

The curiously named Cuckold's Corner, which marked the end of the former Via Principalis through the Roman fortress walls, was subsumed into this space and the meeting of the ancient Stonegate and Coney Street was changed beyond recognition. This brave and, fortunately limited, act of city planning, however, provided the ingredients for a much-improved setting for the house of the lord mayor, the Mansion House, which was in part borne from frustration that the mayor wasn't spending enough time in the city.

Seemingly guarding the fifteenth-century Guildhall, which is reached through the sloping tunnelled carriageway, the Mansion House stands on the site of the medieval Common Hall gatehouse that was referred to in 1256 and replaced The Cross Keys Inn (a potential reference to being at the gateway of the main road to the Minster of St Peter, Stonegate?).

The building notably has the distinction of being the first purpose-built lord mayor's residence in the country. Its distinctive classical form, bright-red render and highlighted stone quoins, white pilasters and details are the subject of many a York Christmas card and the building is still a true icon of the city.

The architect was thought by Pevsner to have been the local architect John Etty, and there are similarities, identified by the Royal Commission, with the Queen's Gallery at Somerset House in London, which sports similar use of classical proportions that may have given some inspiration.

The interior too is just as grand, with the state room occupying the whole five-bay width of the first-floor frontage. Within, the rich plethora of Corinthian pilasters, pediments and cornices echo the high classical aesthetic and must have contributed significantly to the status of York at the time of its construction in 1724, despite delays meaning that the building's completion was not until 1733.

Today the building is open for visits – or at least will be following extensive refurbishment – and will likely contribute once again to York's offering of beautiful wedding venues as well as maintaining the associated regalia, including the Sword of State and the 'Cap of Maintenance' worn by mayors over the ages and dating from 1580.

The recently restored Mansion House. Note the beautiful railings and lanterns: a house fit for a mayor indeed!

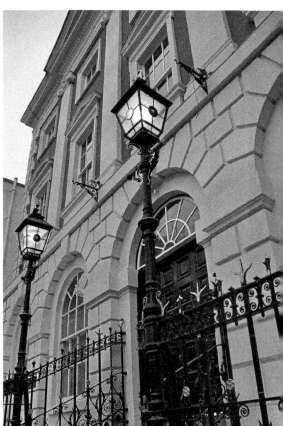

Detail of the lanterns on the Mansion House.

33. The Assembly Rooms (1732)

The Assembly Rooms on nearby Blake Street continued the Georgian renaissance of the city as another national first. It was in a direct response, from the great and the good of the city, to create a purpose-built entertainment hall worthy of the Georgian luxury that was now playing such a key part in the economic resurgence of York.

Now, perhaps, it is one of the most overlooked buildings of significance in York. This is largely because the building was the first neoclassical building in Europe, which is some claim to fame for the city.

The building was designed by Richard Boyle, 3rd Earl of Burlington, in 1730 and creates a faithful response to classical architecture by being an attempt at an authentic reconstruction of a so-called 'Egyptian Hall', described by Vitruvius and illustrated by the sixteenth-century Italian architect Andrea Palladio.

The hall, which incidentally had nothing to do with Egypt, was an interpretation of the architectural elements that were described by Vitruvius within his ten books on architecture. The peristyle hall, therefore, supported with columns around the edge and opening up into a lofty room, was the perfect answer to the needs of the city's elite and provided for the first time a purpose-built space of assembly, of perfect proportions and perfect classical detail.

The building's appearance was changed, however, in 1828 when a new façade was constructed by J. P. Pritchett, architect. This introduced an even more obvious classical form to the main entrance in the form of a portico and classical columns, but due to its

The details of the later portico that now adorns what was the first neoclassical building in the country.

Right: The portico was a later addition but arguably ultimately made the building even more classical in its appearance.

Below: The setting of this building is unfortunately not quite as its builders would have wanted, but is still an improvement from its role in the Second World War when the building was used as the wartime food office.

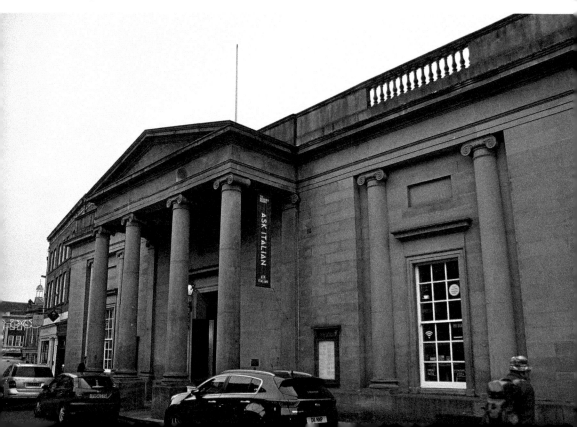

pediment and column bases being located at the far edge of the footway, the grandeur of this building is rarely appreciated.

This is made worse by Blake Street still accommodating parking, when in fact the area in front of the Assembly Rooms should form a true civic space, as it was undoubtedly always meant to do.

However, despite this, the current use is far better than the dark days of the Second World War, when the building was used as York's Wartime Food Office. Never had times appeared so hard in this place of decadence.

34. Theatre Royal (1744–1877)

The original theatre on this site was built in 1744 at the centre of the city's Georgian emerging cultural quarter and overlaid parts of the twelfth-century St Leonard's Hospital. This followed a modest theatre being built to the north of the Minster on what was a tennis court in Lord Irwin's Yard. The new building is shown on the updated Cossin's maps that were edited and added to by John Haynes in 1748.

This modest building predated the construction of St Leonard's Place itself, and originally the theatre would have been within the city's medieval walls with access from Duncombe Place (which itself was much narrower at this time).

The York Theatre Royal extension of the 1960s, praised by Pevsner and a great contextual response to this highly sensitive location.

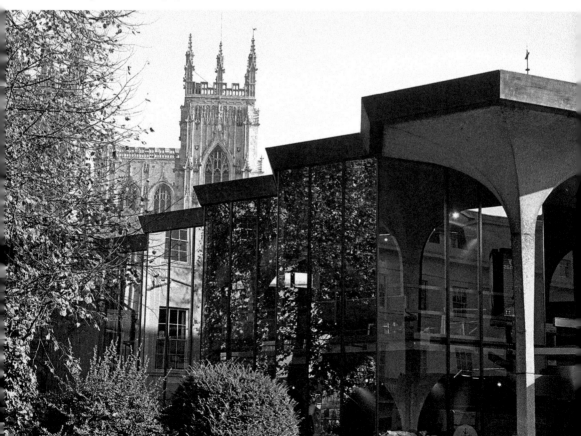

The present building was constructed in 1877 and fronts onto Nos 1–9 St Leonard's Place and is adjacent to the fine De Grey Rooms.

Pevsner has two interesting observations about the theatre building: firstly that it has the appearance of being the Town Hall and secondly, commenting on the 1967 extensions and reflecting on the concrete piers, as being reflective of medieval Gothic vaults. Indeed, the slender legs, upon which the polygons of the 1960s roof sits, do have all the minimalist stature of a perpendicular Chapter House and are a fantastic example of early contextual modernist design, especially in the way the surrounding buildings are reflected in the expanses of glazing.

The extension works very well, however, and the recent refurbishment has seen the large windows cleaned and the café inside improved. A thriving amateur dramatics scene remains in the theatre and the building is only lacking a fitting pedestrian space outside of it, as St Leonard's Place itself is still choked with traffic – hardly what the early nineteenth-century creators had in mind.

35. Micklegate House, Nos 88–90 Micklegate (1752)

The Royal Commission on Historical Monuments in their survey of 1972 simply state that this building is the most important Georgian residence south-west of the Ouse and its seven-bay symmetrical design, with strong central gable all with smart red brick in Flemish

Micklegate House, the city home of John Bourchier of Beningbrough, is a notable example of the Georgian gentrification of the city's main approaches.

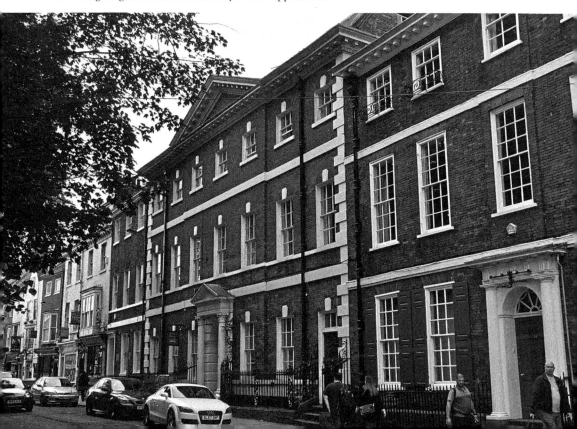

Detail of the classical doorway with Corinthian columns.

bond and stone quoins, leaves the visitor in no doubt that this building is one of some considerable importance.

The house was built for John Bourchier of Beningbrough in 1752 and the architect attributed with its design was John Carr. If one looks closely, the water hoppers at the top of the downpipes bear the initials of Bourchier and his wife Mildred.

Again, like Ingram and his almshouses, Bourchier insisted on the same quality for his town house as he did for his own home at Beningbrough Hall, which was built by him thirty years earlier and reflects John's travels in Italy, where he likely developed his taste for baroque architecture.

Like many buildings in York, the house has suffered over the years and prior to listing, much of the panelling was removed. Even a fireplace was sold off and ended up in the Treasurer's House. However the stairs, ceiling and railings are unique and of exceptional quality and even though the building is now used as a hostel, its grandeur is still apparent and pleasing for the visitor.

36. Pikeing Well, New Walk (1752)

The Pikeing Well is an unusual building and one that is relatively unknown to visitors to York, but this should not remove any significance from this little structure.

It is located along New Walk, which was a new grand public realm scheme of the eighteenth century, laid out by the city authorities and synonymous with the newly fashionable status of York in the Georgian period. Oddly enough, the laying out of this

Above: The Pikeing Well when approached from New Walk.

Below: The classical details have mainly faded now but the structure still appears solid and is a grand statement.

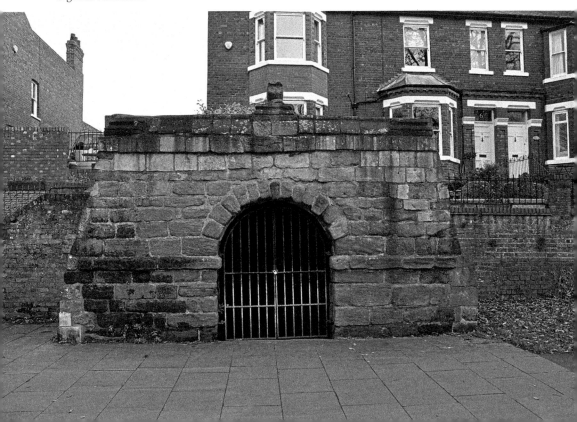

quality tree-lined piece of public realm has arguably never been bettered since. This led Drake to talk extremely fondly of the new scheme in his book *Eboracum* in 1736.

Halfway along New Walk emerges an ancient natural spring that was to become York's answer to the Spa town trends of the time, and the water was deemed to have purifying properties, especially for the eyes.

In order to further improve New Walk, and possibly to contain the spring water better, a formal well head to cover the well was felt necessary. The city authorities eventually commissioned the architect John Carr to design the covering and his response was suitably grand and neoclassical.

The structure reuses some ornate stonework and pilaster bases and there was a legend that the stone chancel from All Saints, Pavement, was relocated here in 1752, although All Saints itself was not demolished until 1782.

Part of the fee paid to John Carr was retained by the city for his Freedom of the City and £25 was deducted from his £88 invoice.

Two years after the construction of the well head, Carr's design was chosen for the new grandstand at the Knavesmire racecourse, and so began his rise to fame as one of Yorkshire's most famous and prominent architects.

37. Fairfax House, No. 27 Castlegate (1762)

Fairfax House is perhaps the finest of a series of fashionable, brick-built, classical town houses to have populated York in the eighteenth century. It stands on Castlegate within the heart of the city and was well placed but far enough away from the glam and glitter of Georgian excess to be supremely comfortable.

The view down Castlegate with St Mary's steeple in the background – a classic York view.

Fairfax House, complete with
Christmas wreath on the door. Inside,
the house will be decked to suit, just as
it was in its eighteenth-century heyday.

The building stands elegant in its symmetry and the classic view, with the ancient St Mary's
Church in the background, is actually to be had from the castle car park. Historically, of
course, this view would have been blocked by the castle walls as the road took its abrupt
right-angle turn onto Tower Street, which skirted south alongside the walls. They were only
demolished in 1936.

The house is Grade I listed for good reason, as it contains what is perhaps the finest
plasterwork in Yorkshire. The house in its present form was created by York architect
John Carr and, if the classical lines were not giveaway enough, the attention to detail
confirms this association.

Inside, the rooms now exude all their Georgian glory and give a wonderful sense of the
eighteenth-century 'well to do' of the time; but it wasn't always like this.

Following the death of Charles Fairfax the property passed to Anne. However, Anne
never had an heir and the house subsequently passed to various notable families before, as
so often happened, the building became a dance hall, a gentleman's club and then a cinema.

This whole later life, accessible to the masses, does actually enhance the building's
interest and talks a wonderful social story amid a real work of art.

38. The Bar Convent, Blossom Street (1766)

The Bar Convent is one of York's institutions. Standing just outside the city walls near Micklegate Bar, the main building represents a very fine eighteenth-century range from the outside, but the complex as a whole is an amalgamation of structures dating from 1766 that gradually replaced an older seventeenth-century building in order to provide a home and boarding school for young ladies.

The Bar Convent was the result of work instigated by Mary Ward, a pioneer in the education of women and a relative of some of the perpetrators of the gunpowder plot of 1605. Arrested by the then pope for her views on equality, Mary ultimately persuaded the church to allow her education of ladies to continue and the convent became synonymous with this cause, its pupils being referred to as 'The Ladies of the Bar', referring to the proximity of Micklegate Bar.

On the inside of the main building, which is of fine four-storey Georgian symmetrical proportions, the building still retains many eighteenth-century features and successfully welcomes visitors to its museum, café or conferences.

On the first floor, however, there is a complete surprise. Along an unassuming corridor leading from an equally ordinary staircase there is a superb little chapel. The chapel itself is situated to the south of the complex and a simple yet solid wooden door marks its unassuming presence. From the exterior of the building the chapel was hidden by a simple lean-to roof, but inside it exudes all its glory with a nave of relative simplicity, followed by Ionic columns, friezes of golden grapevines and flowers all culminating under the large dome over the altar.

The Bar Convent displays no hint at the chapel hidden within.

Detail of the central clock of the Bar Convent. Notice the perfect proportions of the windows and subtle brick details.

39. Holgate Windmill (1770)

There aren't many hills around the city of York, and the area is renowned for being pretty flat. However just outside the city walls to the west the land is undulating and in some places one could even say steep. There are three hills here that seem a bit of an oddity and this led the York historian Francis Drake to believe that they were man-made by the Romans around the route, which ran through the depression that was called 'Hole-Gata', or Holgate.

Why would the Romans build such earthen monuments? Well the clue is in the name as they are locally known as Severus' Hills after the Emperor Septimus Severus, who died in York.

After a long campaign in the north, the emperor wintered in York with his retinue, but surrendered to his advancing years and perhaps the harshness of the northern winter, and died within the city in February AD 211. He was cremated on top of one of the hills in Holgate where there was already a Roman cemetery and ever since the hills have borne his name.

There isn't much to see now of the mounds that appeared so prominent in Drake's day, but there is one landmark that marks the spot of one of them. Standing high up on a mound surrounded by some typical semi-detached suburban houses that so characterise York's suburbs stands Holgate Windmill, its five white sails contrasting sharply with the black of the brick that forms the rotund mill building.

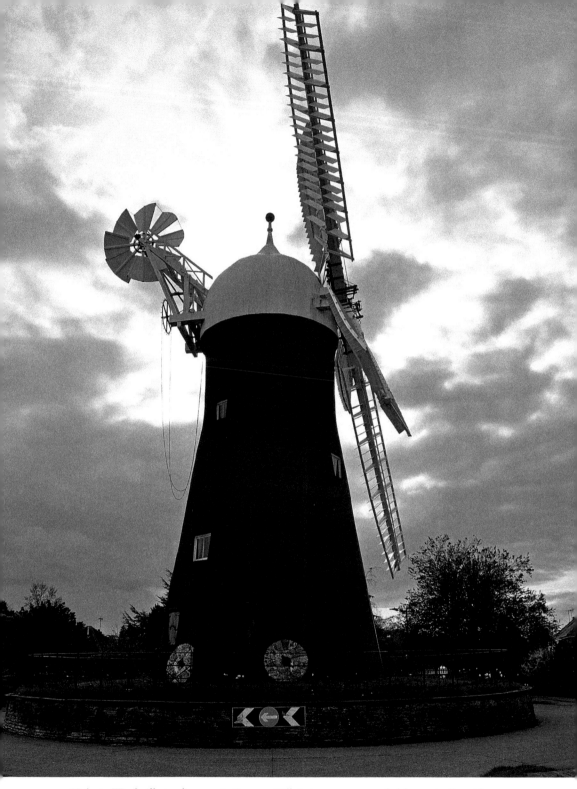

Holgate Windmill standing on its Severus Hill. It is now surrounded by typically mid-century York suburbia, but still offers good views towards the Minster.

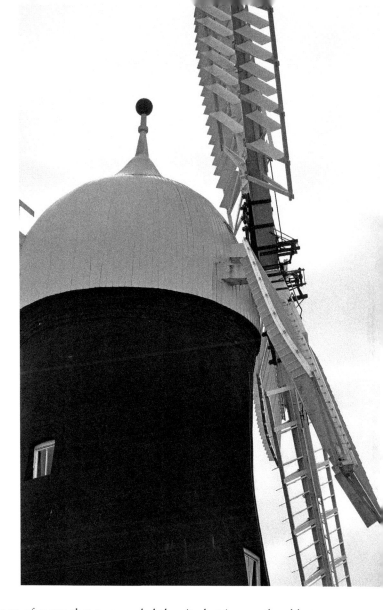

Detail of the award-winning restoration.

The windmill was once one of many that surrounded the city but is now the oldest five-sail mill in the country to survive. Speed's map of 1610 shows several windmills on the Knavesmire, where they caught the cool breezes from the Humber plains to the south. They would once have been a common sight on the strays and undulations within the Vale of York.

Holgate was built in 1770 and the miller was George Maud, whose son and grandson continued the trade until 1851. The mill eventually lost its sails and continued to fall apart until the Holgate Preservation Society was formed in 2001 and managed to raise £500,000 for the mill's preservation. It is now happily restored to its former glory; what's more, the society even won a York Design Award for their efforts.

The mill has a regular pattern of open days throughout the year and as a visitor one can not only see the functioning mechanics inside, but you can also buy some freshly ground flour to take away with you.

40. Female Prison – The Castle Museum (1780)

The Female Prison was built in 1780 to ease the overcrowding in the neighbouring Debtors' Prison. The building is far more recognisably classical in form and appearance than its predecessor and mirrors the John Carr-designed Assizes Court opposite. The building again is built within the old bailey of York Castle and, like the Debtors' Prison, it uses the old castle walls as the rear wall to the former exercise yard and backs onto the River Foss.

The building is now the famous York Castle Museum and its interior has been transformed with displays. Its piece de resistance is the recreated Victorian Street, built from bits and pieces of older buildings from around the country by its founder, Dr John Kirk.

Dr Kirk was an avid collector and amateur archaeologist and often took artefacts in lieu of fees from his patients over the years. When the prison came up for sale he persuaded the city authorities to help in his endeavours to create a museum worthy of the city. He succeeded, but not only this, he recreated whole period rooms furnished with appropriate items and constructed the famous street in a deliberate and highly successful move away from the dusty cabinets of museums past.

The museum opened in 1938 and had a direct influence on other living history museums, such as Beamish in County Durham.

To the casual observer the interior bears little resemblance to a prison, but when observed more closely (or following a conversation with one of the helpful Guides) the prison form

The Castle Museum is one of the city's prime tourist attractions, where the recreated city street shows life in the nineteenth century.

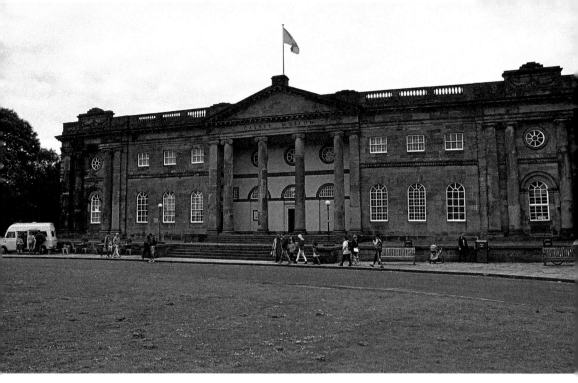

The classical façade of the Female Prison.

suddenly emerges from behind its theatrical façade. The archway between two ancient buildings can suddenly be seen to be one of the larger ground-floor cells, complete with vaulted roof.

The long corridor, with doors every few metres, is an unmistakable service corridor and the large open space, now the street, was the former exercise yard, now suitably covered over and given the special effects of changing light and times of day.

The cell of the condemned is appropriately fitted out as an undertaker's workshop, but outside this room, facing the car park, the opening from where many a hanging took place is still visible.

41. De Grey Rooms, St Leonard's Place (1842)

The De Grey Rooms are synonymous with the great tradition that the city has with the army. Ever since Roman times York has been a primary headquarters for the army and the De Grey Rooms were purpose built by subscription in 1841–2 for the Yorkshire Hussars for use as an officers' mess.

They were designed in a grand neoclassical style by the architect of the York railway station, Mr George Townsend Andrews, and named after the then Commander-in-Chief of the Yorkshire Hussars, Thomas Phillip De Grey.

The rooms are still used for entertainment, dances, concerts and balls and are under the custodianship of the York Conservation Trust.

The white render still produces a cleanliness in the city and, again, adds significantly to the grandeur of St Leonard's Place, an area so much more worthy of a truly civic space. Indeed, perhaps one day the building's setting, along with that of the Art Gallery and Theatre Royal, will be improved.

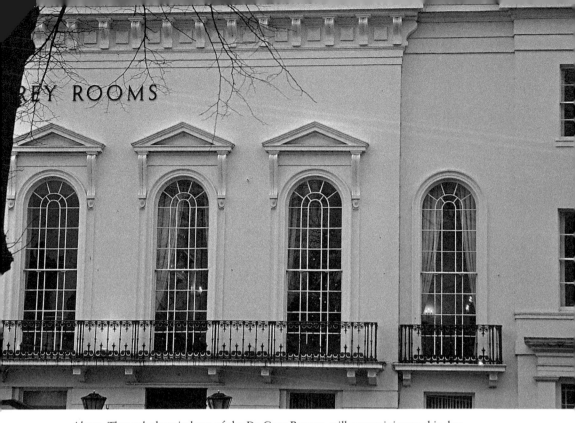

Above: Through the windows of the De Grey Rooms, still entertaining to this day.

Below: Detail of the white-rendered stucco, classical details and pediments that grace the outside of this fine building.

42. Nos 1–9 St Leonard's Place (1844)

The off-white stuccoed façade of Nos 1–9 St Leonard's Place was built in 1844 to a design by architect John Harper and sold on ninety-nine-year leases from the city authorities. The development is perhaps the grandest classical terrace of its type in York and is located in the area of the former Royal Mint and the medieval hospital of St Leonard's.

The creation of the street represents a trend at the time to 'release' the city from its tight girdle of medieval walls and, in 1800, the city council applied for an Act of Parliament to demolish the walls, as it was felt they hindered economic prosperity. This was fortunately resisted, but not before St Leonard's Place completed its breakthrough to this part of the city with the intention to create a street 'for genteel private residences' and the terraces 1–9 are the result.

John Harper himself had a house here, as did the Yorkshire Club (who later objected to the creation of offices for the poor to be located nearby). Most recently, however, the grandest of York's crescents was occupied by the City of York Council and it was from here that the planning decisions for the city were taken by officers occupying the faded grandeur of the principal rooms.

Inside, the municipal use had kept most of the features, cornices, fireplaces, ceiling roses and even the original 'Crapper' toilet complete with thick mahogany seat.

The layers of dust were finally removed in 2016 when enlightened developer Rushbond recently returned the crescent back to its original use, with a price tag to match, the only problem being that the occupants' Bentleys sometimes can't fit into the modest garages to the rear.

Across the road from the Theatre Royal and De Grey Rooms is perhaps the finest terrace in York: St Leonard's Place. Once the city council offices, it is now luxury homes once again.

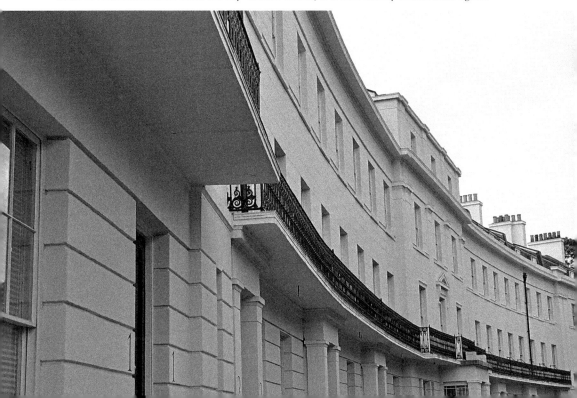

43. Old Station, Railway Street/Tanner Row (1847)

The original 1841 railway station fortunately still survives in York. The similarities to Hull (1847) are easy to see as both were designed by the railway architect, G. T. Andrews and both, at the time, were the end of the line.

This dramatic evolution in transport was disastrous for the stagecoaches that had made their way towards The Black Swan inn on Coney Street for years, and they soon found themselves usurped by the new, much faster railways.

Even though coach travel had improved dramatically from four days between York and London in 1706 to a mere thirty-six hours by the end of the era, and despite the drama of having six black horses pulling a carriage on new turnpike roads, there was little the coach lines could do.

The first halt was a modest affair in a single hut, but the success soon led to the building of the first proper station before the lack of a through route led to the building's redundancy.

The building's sandy-grey brick provides a main range now facing the former headquarters of the GNER Co. and two wings extend south to embrace the old route of the railway that punched a large, but rather neat, hole through the historic city walls to make its entrance.

The track layout was designed by the famous engineer George Stephenson, but the station soon outgrew capacity, which resulted in only eighteen trains a day using the station in the end.

The building is on the site of older structures, most notably the city's Roman baths that dated from the second century AD, medieval Dominican friary and the York House of Correction, which was only constructed twenty-six years before the station required its demolition.

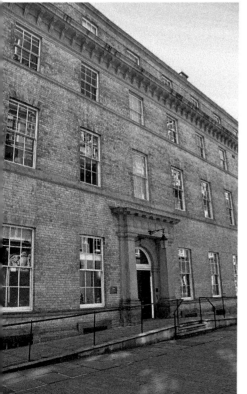

York's first station is now the new headquarters for the city council.

In 2014, the buildings were converted for the use of the City of York Council in order to condense their estate. The move to open-plan offices (quite a change from the parlour offices of St Leonard's) enabled a lightweight atrium space to be constructed on the same footprint as the old railway platforms, so the building can still be appreciated and is still, to a large extent, publicly accessible. Although the public space is not quite as open as one would like, it does represent an appropriate reuse and reinterpretation of this very important building in the city's railway history.

44. York Railway Station (1877)

For many the first sense of York comes as their train pulls into York railway station. Once the longest railway platform in the world, the station reflects the designs of other mainline stations along the east coast line and was, notably, built on a curve in the line that allows the cast-iron arches to show all their glory as they filter the light and concertina into the distance.

The station was designed by the railway architect Thomas Prosser, opened on 25 of June 1877, replaced the older station that terminated within the city walls and had no through route.

The new station was of similar materials, buff engineering brick (imported by the railway itself) and stone details, nowhere near as grand as some of the London stations, but inside the Corinthian columns and coloured spandrels sporting GNER coat of arms, together with the sheer space and size, is awe-inspiring.

Nearby, the National Railway Museum still shows off the engines and royal coaches that at one time frequented York and, if you are lucky, the station is still a destination for the older steam engines, their soot still blackening the steel girders above.

The almost art deco style of the York railway station as the spans of the iron roof project outwards.

The distinctive roof built on the curve of the station gives us this wonderful view, the structure diminishing as it extends.

45. Former GNER HQ, Now the Grand Hotel and Spa, Railway Street (1906)

Pevsner describes this giant Edwardian building as being 'All very lavishly handled', and apart from the huge telecommunications mast on its roof, it is! The red-brick and stone dressings with belle époque-style tiered dormers all exude the confidence of the railways at the turn of the twentieth century. The details, coats of arms and luscious red-brick and sandstone must have seemed very grand indeed to the inhabitants of this part of the city, where Georgian town house façades more often than not covered ancient medieval timber frames that lined the old Roman route into the town.

The building is now one of York's most luxurious hotels and the first impression of the grand staircase from the lobby says it all, with chunky balustrades and thick Yorkstone steps curving up to the generously proportioned landings, corridors and rooms contained within.

The basement is now part of the hotel spa and is exciting for two reasons: firstly the pool, spa and massage rooms are on, or very near, the very same spot of the Roman baths; and secondly, the rooms are all contained within the monstrous steel safe doors of the GNER vaults. So not only can the visitor swim in the baths of the Romans of Eboracum, but one can also pretend to be swimming in the mountains of gold that once perhaps resided here!

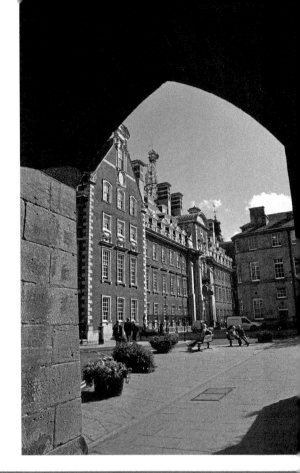

Right: The elegance of the former GNER headquarters, now the Grand Hotel and Spa.

Below: The tiers of dormer windows so very belle époque.

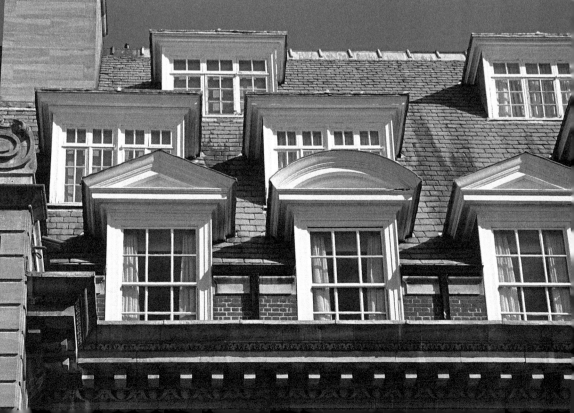

The coat of arms of the North Eastern Railway still adorn the outside.

46. Folk Hall, New Earswick (1907)

The Folk Hall was built in 1907 by Joseph Rowntree. It was the primary community building within his model garden village designed by Parker and Unwin.

New Earswick was an important evolution in residential design and was heavily influenced by the Arts and Crafts movement of the late nineteenth century and the writings of Ebenezer Howard. The curving streets, large gardens and attention to detail effectively gave birth to modern suburbia, but the village itself was far more sophisticated than this and still offers us valuable lessons today.

The Folk Hall stands to the south of the village and is the community hub for the residents. Its design is actually much more flamboyant than the typical simplicity of the Arts and Crafts houses of the area, with its overly large red pantile roof and bulky white rendered walls giving a more fantastical appearance. However, despite this, the form of the building has gone on, rightly or wrongly, to inspire the newest Rowntree village of Derwenthorpe to the East of York where the new houses are perhaps a little more 'Folk Hall' than 'Arts and Crafts' inspired.

Despite this, the Folk Hall was so successful that Raymond Unwin was commissioned to design an extension to the original in 1935, due to extra demands for space. Inside, the building still functions much in the same way as it always did with concerts, functions and a café, with a wonderful early twentieth-century feel. It is a true 'focal point' community building harking back to the English vernacular, and the fact that it still functions as it always did is a credit to the Joseph Rowntree Housing Trust, who still maintain the village and use it to inspire new communities of the future.

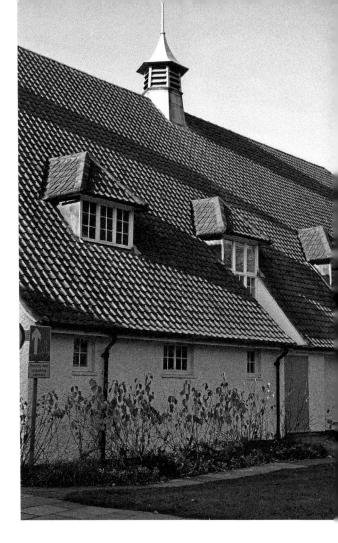

The Folk Hall harking after simple, vernacular forms but with a peculiar Arts and Crafts feel.

47. Odeon Cinema, Nos 1–5 Blossom Street (1937)

Constructed during the Hollywood heyday of the 1930s by Harry Weedon, the York Odeon expresses Art Deco design perhaps better than any other building in the city.

Although almost brutalist in parts, and at the time restricted from being constructed within the city walls, its red-brick construction still has lessons for us today in how to integrate new architectural forms into a rich, historic context.

Its elongated metal windows, original grille details and red-brick tower feature create an excellent example of 1930s cinema design, of which Odeon was a leader.

Of course, the cinema has changed hands over the years and was left unoccupied in 2006 when the Odeon company mothballed the site. The result was that the cinema was boarded up and under significant threat. This led to a campaign by the York Press entitled 'Save Our Odeon' and it obtained 13,000 signatures in support of the building's preservation, not least of its most distinctive feature, the original Odeon neon sign, which was considered under significant threat from its rivals, who, perhaps understandably, didn't want the name of their main competitor lording it over their own brand!

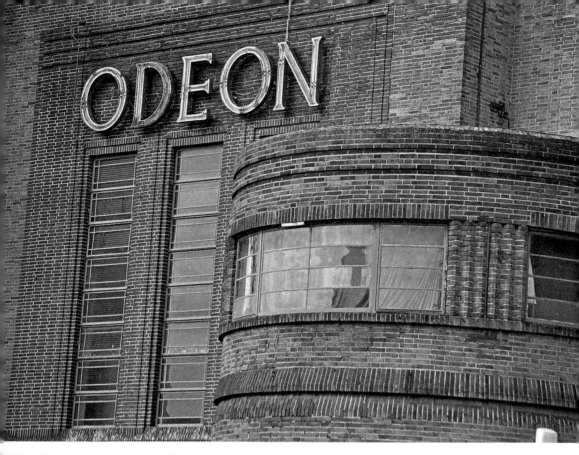

Above: The unashamedly modernist Odeon cinema with brick masterfully creating all shapes and forms.

Left: Detail of the original Odeon neon signage.

However, with the protection of a Grade II listing the loss, or temporary covering up, of this sign was avoided and the Reel cinema did the right thing and kept the building in its original function.

The latest part of the story involves the change of the cinema to the luxurious Everyman brand, which neatly returns the cinema to its roots, except this time cinemagoers can sit wine in hand alongside their popcorn as they watch the latest blockbuster ... or art house classic.

The sensitive changes being made to the cinema, as part of this development, include the removal and re-emergence of the original auditorium ceiling that has lain hidden beneath a suspended ceiling for many years.

48. Stonebow House, Stonebow (1962)

Stonebow House is a fine example of a modern building imposing upon a much older townscape. It was built at a time when huge areas of nearby Hungate had been demolished and perhaps the architects felt that this process would, or should, continue. The building is brick and precast concrete and does make some attempt at reflecting the historic street pattern in the way it curves to join Peasholme Green and Pavement, a link that was historically accommodated by the wonderful St Saviourgate.

However, despite the building by Hartley, Grover and Halter having few architectural credentials, the impact upon York was great and the environment that the building created in St Saviourgate is rather unforgivable as it hides some architectural and historic gems.

The cantilevered main block of Stonebow House, dominating this part of the city.

This elevation faces onto one of York's oldest streets and represents a fundamental flaw in modernist town planning.

Nevertheless, Stonebow House was, like it or not, of its time and did reflect the blind confidence of the era. The building has also finally found a place in people's hearts, not least through its use as vibrant music venue Fibbers, with calls for it to be listed in 2016 when the building's owners put it up for sale.

Of course, demolition was never a real threat, as when else would a developer get the opportunity to erect such a high structure into the area today? The result will soon be revealed as the building is stripped and re-clad, losing all the '60s aesthetic appeal but hopefully not leaving the streets fronted by graffiti-clad walls like its predecessor.

49. Central Hall, University of York (1964)

York University's Heslington East campus was built in 1964 just four years after its formal foundation as a university focused around the Elizabethan Heslington Hall. Despite the hall being largely rebuilt in the nineteenth century, the campus took up much of the estate's parkland to the east and completely altered the setting of the building.

The campus was one of a flurry of universities who adopted modernist design principles to the full, and although the modern architecture is not as accomplished as some other regional universities – such as the University of Leeds with it's recently Grade II*-listed Chamberlain, Powell and Bon 'Roger Stevens Building' – the campus at York still

Central Hall reflecting in the balancing ponds of the university campus.

Like it or not, Central Hall is a dramatic building and suitably meets the brief to be a true focal point within the campus.

incorporates segregation of traffic, modern forms and materials and the rich landscaping so characteristic of the time.

On 22 October 1965 the campus was opened by Queen Elizabeth II and she was recorded as saying how she admired the old Heslington Hall but was not impressed by the new colleges.

The site was a difficult one to work with and, due in part to extremely boggy conditions of the land, a lake was intentionally created as a focal point among the landscapes of Frank H. Clarke.

Protruding into this lake, surrounded by mature willow trees whose limp limbs trail the water's edge, is the university's Central Hall designed by Andrew Derbyshire, architect. The building is a great pyramidal structure, almost an inverted ziggurat form with a narrow base with entrance lobby that still divides opinion, as was reflected in a recent *Independent* article where it was cited as being one of Britain's ugliest buildings!

The building does look as if it has just landed from outer space and the quality of the materials isn't perhaps the best, but, as a building, as a focal point and as a landmark, it certainly works.

On entering the building the approach takes you over covered bridges, (covered walkways are a very civilised theme throughout this part of the campus) and the first thing that hits you (almost literally at times) on entering the glazed lobby beneath the tiers above is the low roof of the foyer.

The flooring and plinth of the building is solid York brick, the large-scale floor to ceiling windows create a wonderful antechamber space overlooking the lake, and the circular room is typical sixties in its execution.

The roof is so low that one almost wants to escape its confines, and when ascending the steps the release is great, as the whole building suddenly makes sense as the size and shape of the arena above is revealed in all its glory. The stairs lead up and the whole spectacle feels like entering a stadium as you ascend and then descend into the theatre.

The building has been described as having 'dry' acoustics and attempts have been made over recent years to address this, but the wide remit of uses, including graduations, dances, theatre performances and even the Church of England annual synod, make this a worthy modern building in York.

50. Hiscox Building, Peasholme Green (2016)

One of the most recent buildings to join the townscape of York is the Hiscox Insurance building on Peasholme Green by Make Architects. It is a brave building in the fact that it is sited so close to the seventeenth-century Black Swan pub, whose reflection morphs and changes in the curving glass façade rather like it is within a hall of mirrors. Inside, the lobby is polished concrete and the architects tried to create an informal, communal space for the 500 employees based here. The stairs hark after the city walls, which, at face value at least, is not the most original element to take inspiration from; but, on inspection, they do actually reflect the rhythm of short stairs and landings that can be seen along certain stretches of the city walls.

The most striking feature inside, however, is a decommissioned communist rocket, aiming itself out of the elongated skylight above. It isn't exactly comforting but it certainly leaves an impression…

Above: The Hiscox Building with its stark curtain walling reflecting its surroundings. There is nothing particularly original about this approach, but it does seem to work.

Below: The Minster tower in the distance, but where is the modern building? Almost invisible behind its expanse of reflective glazing.

As the sun sets, the Hiscox Building reflects the medieval Black Swan pub and gives us a sense of the 'Continuing City'.

Outside, the building attempts to fit in through its use of brick walls and highly reflective glass. This is a tried-and-tested approach, but it is also the safe option and the only hint at flamboyance is the glass and curved brick panels that apparently reflect the historic wool market in the Hungate area.

Nevertheless, this building is a worthy addition to York, but how much new ground it penetrates we shall have to wait and see.

Bibliography

Addyman, Peter, *York* (British Historic Towns Atlas, 2017)

Bond, Francis, *English Cathedrals Illustrated* (London: George Newnes, Limited 1899)

Drake, Francis, *Eboracum: Or, The History and Antiquities of the City of York, from its Original to the Present Times* (W. Bowyer, 1736)

Gent, Thomas, *The Ancient and a Modern History of the Famous City of York* (London: Thomas Hammond and B. Bettesworth, 1730)

Hall, Richard, *English Heritage Book of York* (B. T. Batsford/English Heritage, 1996)

Johnson, Matthew, *English Houses 1300-1800* (Routledge, 2010)

Murray, Hugh, *Scarborough, York and Leeds - The Town Maps of John Cossins 1697-1743* (York Architectural and York Archaeological Society, 1997)

Ordnance Survey, Historical Map and Guide, Roman and Anglian York (York Archaeological Trust/RCHM, 1988)

Ordnance Survey, Historical Map and Guide, Viking and Medieval York (York Archaeological Trust/RCHM) 1988

Ottaway, Patrick, *Roman York* (Tempus, 2004)

Palliser, David & Mary, *York as they saw it - from Alciun to Lord Esher* (William Sessions Limited, The Ebor Press, in association with The C, & J. B. Morel Trust, 1979)

Ramsey, Nigel, Willoughby, James M. W. Corpus of British Medieval Library Catalogues 14 - Hospitals, Towns and the Professions (The British Library in association The British Academy, 2009)

Rollason, D. W, Sources for York History, The Archaeology of York Volume 1. (York Archaeological Trust, 1998)

Royal Commission on Historical Monuments, City of York Volume I EBVRACVM Roman York, (HMSO, 1962)

Royal Commission on Historical Monuments, City of York Volume III South-West of the Ouse (HMSO, 1972)

Royal Commission on Historical Monuments, City of York Volume IV Outside the City Walls. East of the Ouse (HMSO, 1975)

Royal Commission on Historical Monuments, City of York Volume V The Central Area, (HMSO, 1981)

Royal Commission on Historical Monuments, York Historic Buildings in the Central Area – A Photographic Record, (HMSO, 1981)

Stacpoole, Alberic, *The Noble City of York* (York: Cerialis Press, 1972)

Willis, Ronald, Portrait of York (London: Robert Hale, 1972)
Online Resources:

English Heritage
History of York webpage by York Museums Trust
National Trust
Wikipedia
York Civic Trust,
York Medical Society

Acknowledgements

The author would like to give huge thanks and gratitude to those who supported him in the writing of this, his first, book. Most notably his amazing wife Suzie, who offered unwavering support throughout this project just because she knew how much it meant. Also to his mum, who proofread for days and accompanied him on many trips to York, patiently waiting for him to get the right image for each building. Thanks also to the Churches Conservation Trust, Merchant Adventurers and the Dean and Chapter of York Minster and all the professional and personal friends who have assisted in many little ways. Finally, a big thankyou to the staff at the Leeds Library who eventually gave him the nickname 'Drake's Eboracum' because of his all too frequent visits to read the original book which is in their amazing collection.

About the Author

Andrew Graham is a practising urban designer, architectural historian, photographer and heritage professional working in Yorkshire. He is a CABE Built Environment Expert and sits on the Fabric Advisory Committee for York Minster and Ripon Cathedral. He is also a full member of the Institute of Historic Building Conservation. This is his first book.

Also available from Amberley Publishing

This fascinating selection of photographs exploress some of the
much-loved current and historic pubs of York.

978 1 4456 4470 7

Available to order direct 01453 847 800

www.amberley-books.com